BASEBALL
IN
NASHVILLE

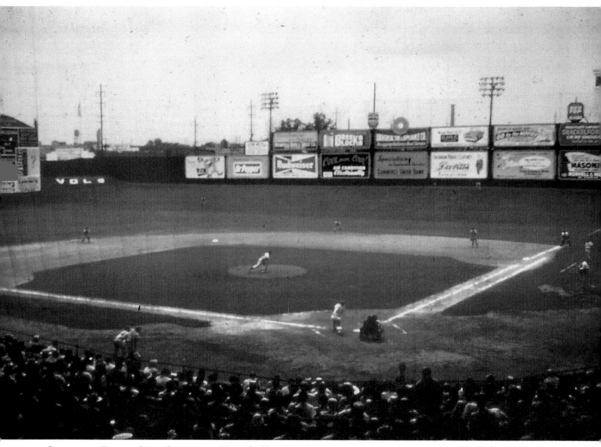

SULPHUR DELL. Once known as "Baseball's Most Historic Park Since 1870" and given its name by Grantland Rice while he was a sportswriter at a local newspaper, Sulphur Dell was the home of the Nashville Vols in the Southern Association from 1901 until 1961 and in the South Atlantic League in 1963. The Negro League Nashville Elite Giants called Sulphur Dell their home in the 1930s. The memories remain for many who visited the old ballpark—long gone but not forgotten—and cheered for the Vols, Elite Giants, and amateur teams who played there. (Courtesy Metropolitan Government Archives of Nashville and Davidson County.)

FRONT COVER: Not reaching the major leagues until he was 33 years old, "Milkman" Jim Turner played for the Boston Bees, Cincinnati Reds, and New York Yankees. This native Nashvillian became one of the premier pitching coaches for the New York Yankees in the 1950s until taking the reins of the Nashville Vols in 1960 as manager and vice president. He returned to the big leagues with the Cincinnati Reds as pitching coach in 1961. (Courtesy Jim Turner Estate.)
COVER BACKGROUND: The background is the Nashville Vols team photograph from 1943. (Author collection.)
BACK COVER: The guitar-shaped scoreboard is a fixture at Herschel Greer Stadium, home of the 2005 Pacific Coast League Nashville Sounds. (Courtesy Nashville Sounds.)

BASEBALL
IN
NASHVILLE

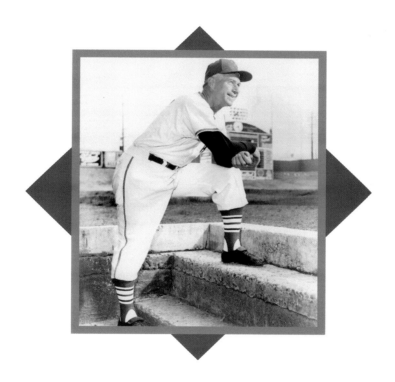

Skip Nipper

ARCADIA
PUBLISHING

Published by Arcadia Publishing
Charleston, South Carolina

Printed in the United States of America

Library of Congress Catalog Card Number: 2006934705

For all general information contact Arcadia Publishing at:
Telephone 843-853-2070
Fax 843-853-0044
E-mail sales@arcadiapublishing.com
For customer service and orders:
Toll-Free 1-888-313-2665

Visit us on the Internet at www.arcadiapublishing.com

This book is dedicated to my father, Virgil Nipper, whose minor-league career was short-lived but his love for baseball remains long. He taught me everything I know about the game, but he especially taught me how playing baseball can build character by putting one in a position to make sound but quick decisions nurtured by practice, practice, practice. He enjoys sitting behind the plate at Nashville's Greer Stadium, the perfect spot for a former catcher to relate his experiences on the field. He is still the best baseball player I ever knew.

CONTENTS

ACKNOWLEDGMENTS

The author wishes to express his gratitude to those who have contributed advice, photographs, stories, and insight of their recollections of Nashville baseball: to Virgil Nipper, a dedicated father and baseball sage whose stories have been told and heard around the dinner table for over 50 years; to Sheila Nipper, who allows a man with a boy's love for baseball to not get in the way of a happy marriage; to Jim Nipper, who was the best competitor in backyard Wiffle ball games and the best brother anyone could have; to Jane Woodruff McIntyre, high school English teacher extraordinaire; to Julian "Junie" McBride, Nashville's "Mr. Baseball," the only person alive to have seen games played at old Sulphur Dell before the park was turned around in 1927 and who has the best memory of anyone; to Bill Traughber, a local sportswriter willing to share his research and whose work is envied above all others; to Farrell Owens, former executive vice-president of the Nashville Sounds, whose recollections of amateur and professional sports are treasures; to Ken Fieth, Debie Cox, Paul Clements, and the staff of Metro Archives, Nashville, Tennessee, but especially archivist Linda Center, whose love of baseball has highlighted Nashville's baseball history with outstanding exhibits; to Beth Odle, Nashville Public Library, the Nashville Room, for her assistance in researching photographs; to David Brewer, Clarence "Skip" Watkins, Derby Gisclair, David Jenkins, and members of the Southern Association Reunion Conference who freely share their knowledge of the old league; to Tony Roberts, Fred Sadler, Mickey Holton, Larry Taylor, Roy Pardue, and Warren Corbett, who have given first-hand recollections of games at Sulphur Dell; to the Nashville Old Timers Baseball Association board of directors, who keep the memories alive; to Clinton "Butch" McCord, former Negro League and minor-league player whose unselfishness to share his baseball thrills and disappointments helps one to understand baseball and life in America; to Doug Scopel of the Nashville Sounds for helping to put the team's story in order; to Tim Wiles of the National Baseball Hall of Fame, who offered assistance and guidance; to Maggie Bullwinkel of Arcadia Publishing, whose patience and encouragement made this endeavor possible; and to my entire family for their support.

INTRODUCTION

From the time Union soldiers first camped on the banks of the Cumberland River and taught their Northern game to Nashville's ball players until the Nashville Sounds won the 2005 Pacific Coast League's championship, baseball's influence on people from all walks of life has been deep, contributing to the shaping of Nashville's diverse culture, schools and universities, and families.

At one time, deer and buffalo searched out the area known by pioneers as French Lick Springs, and as the population began to grow, citizens made the former watering and trading spot their picnic and recreation grounds. Nearby was also a natural sulphur spring that people sought out, and residents filled their empty containers with the odorous liquid to use for its medicinal qualities or took a drink right from the spring at Sulphur Springs Bottom.

Eventually citizens met there for sports activities, and baseball became their favorite diversion. A portion of the grounds was designated as Athletic Park as the need arose for a specific area to play the popular game. Interest in baseball grew throughout America, and as the first professional baseball leagues flourished, the first local amateur and semi-professional teams in Nashville were formed. The first professional team organized to join the newly formed Southern League in 1885 was the Nashville Americans. Thus began Nashville's recorded history of baseball activity.

In 1908, Grantland Rice, sportswriter of the *Nashville American* and graduate of Vanderbilt University, mockingly renamed the ballpark "Sulphur Dell." Rice had played baseball while enrolled at Vanderbilt and had an opportunity to play for the professional Nashville Baseball Club in town except for the disapproval of his father. When the chance came to work for a local newspaper, Rice reluctantly took the job but eventually honed the skills that helped him develop into "The Dean of American Sportswriters," as he was often referred to by his peers.

Ballparks sprung up around town as the city experienced tremendous growth, and amateur teams abounded in the 1930s and well into the 1950s. Local leagues formed; the most popular league was the City League. Former major-league players were known to return to Nashville after their professional careers were over to play in the City League and earn a few extra dollars playing among quality talent.

With the demise of the Nashville Vols in 1963, Sulphur Dell was torn down, leaving the city without professional baseball until being resurrected again in 1978 by a group of local investors led by Larry Schmittou. The team began a gallant run of recognition concurrent with the rise in popularity of country music. Schmittou added popular local performers and top stars as investors, and attendance rose as he learned that promotions and a quality team on the field brought fans into the stadium.

In 2005, the Nashville Sounds won the Pacific Coast League championship, bringing the city the championship it had longed for after many seasons of close calls and resurrecting a renewed pride in its baseball heritage.

BULLETIN ADVERTISEMENT. This advertisement appeared in the *Nashville Globe* on Friday, July 4, 1913. (Courtesy Metropolitan Government Archives of Nashville and Davidson County.)

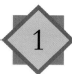

ATHLETIC PARK

Base Ball—This healthful and exciting exercise was very generally popular this fall, especially in the Northern States, and we hope it will be introduced here as soon as the heated term passes off. We noticed the other evening a party engaged in Base Ball on the Edgefield side of the river, all apparently enjoying themselves. The early closing of the stores gives a fine opportunity to the young men engaged in mercantile pursuits. . . . Let us have Base Ball Clubs organized, then, and the fun commenced.

—*Nashville Republican Banner*, Wednesday, July 25, 1860

Nashville resident Herman Sandhouse, who attended college in Philadelphia, was an early baseball teacher and instrumental in the organization of the first amateur team, the Pontiacs. Additional teams began to form, such as Linck's Hotel, the East Nashville Deppins, and the Nashville Maroons. The Nashville Athletic Club (NAC) became the team that most players yearned to play for, as the NAC furnished uniforms. The place they wanted to play was at the real ball diamond in town. According to the September 12, 1866, *Nashville Republican Banner*:

> At the match game for a fine sugar-tree bat, between the Burns and Flynn Base Ball Clubs, at the Sulphur Springs bottom, yesterday afternoon, the Flynn Club scored 25 to 16 in nine innings. This was the second victory of the Flynn Club, and the first match game ever played by the Burns Club.

The original professional team in 1885 was the Nashville Americans, an entry in the newly formed Southern League. In 1887, the team was renamed the Blues but struggled with financial problems and dropped out of the league in August. Although the Southern League continued to operate through 1888, Nashville did not field a team that year or in 1889, when the league disbanded entirely in July.

The league was reborn in 1892. Nashville did not have a team entered, but in 1893, the Nashville Tigers were the hometown representative. Future major-league manager George Stallings began a two-year tenure as Nashville's manager in 1894 with the Tigers and in 1895 with the Seraphs. Stallings played the outfield and first base in 1895, hitting for a .341 batting average while outfielder Frank Butler batted .371.

The Southern League did not last the entire year in any of the next three seasons, and Nashville did not field a team again until 1901, when the Southern Association was organized.

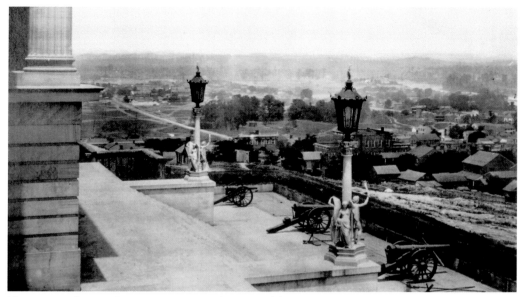

TENNESSEE STATE CAPITOL. In 1862, the second-largest contingent of Union soldiers, next to Atlanta, was stationed in Nashville. This view from the Tennessee State Capitol in 1862 overlooks Sulphur Springs Bottom to the north, later to be known as Athletic Park, an area for playing baseball games. The Cumberland River is in the background and often flooded the low-lying grounds in the spring. (Courtesy Library of Congress.)

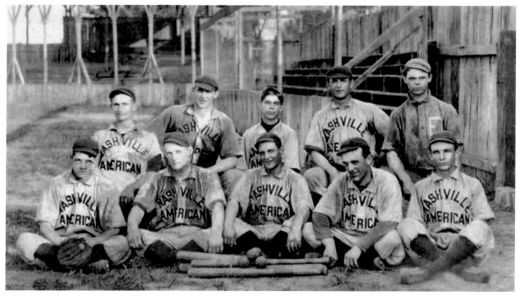

NASHVILLE AMERICANS. In 1885, the Southern League was formed, and Nashville's entry into the new league for two seasons was the Americans. The 1885 team was led by Charles Marr with 129 hits and a .327 batting average. The team finished in third place in the inaugural season. (Courtesy Chris Catignani.)

CAP ANSON. In 1885, the Chicago White Stockings called Nashville their spring-training home for three weeks. Perhaps the sulphur springs near the local park had some effect on the players, as the team won the National League pennant that year. Anson was elected to the Hall of Fame in 1939. (Private collection.)

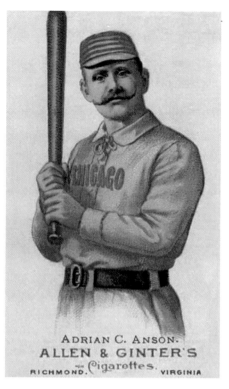

ADRIAN C. ANSON.
ALLEN & GINTER'S
RICHMOND. Cigarettes. VIRGINIA

NASHVILLE MAROONS, 1887. Organized in 1868, the Maroons were one of many amateur and club teams that were formed beginning in the 1870s. This gallant group joined the Phoenix Baseball Club, the North Nashville Juniors, Linck's Hotel, the East Nashville Deppins, and the Nashville Athletic Club as teams in Nashville's earliest baseball tradition. (Author collection, Robert S. Corbitt photograph.)

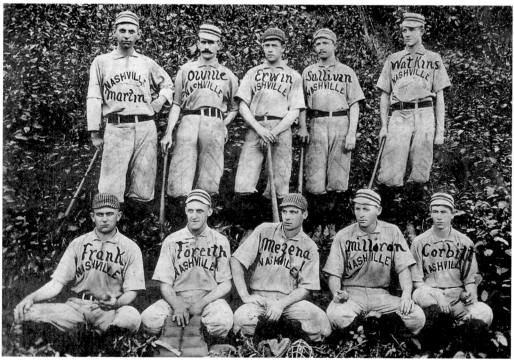

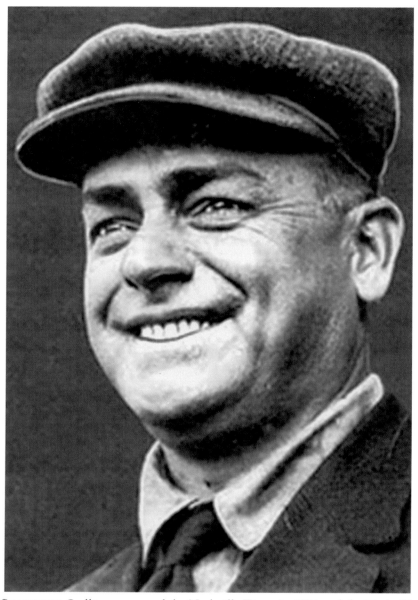

GEORGE STALLINGS. Stallings managed the Nashville Tigers in 1894 and the Nashville Seraphs in 1895 before becoming a manager in the major leagues. In 1895, the Tigers finished in second place in the Southern League, one game behind pennant-winning Atlanta. An average player who only played in seven games in the majors, as manager of the 1914 "Miracle" Braves, Stallings is credited with being the first manager to use platooning with success. His Braves won the World Series that year by sweeping the Philadelphia Athletics four games to none. In 1910, he led the New York Yankees (then known as the Highlanders) to a second-place finish. His major-league managerial record was 880-900. Later in life, when asked why he had a bad heart, according to legend, Stallings said, "Bases on balls, doc . . . those damned bases on balls." (Private collection.)

THE GRANTLAND RICE ERA

The saw and hammer get busy reclaiming the arid waste of Sulphur Spring, which classic spot, with a new set of stands, will be known as Sulphur Spring Dell, and not Sulphur Spring Bottom, as of yore. And Sulphur Spring can take a good block of reclaiming without being visibly hurt by the treatment.

—Grantland Rice, *Nashville Tennessean*, January 14, 1908

Grantland Rice, born in Murfreesboro, Tennessee, on November 1, 1880, earned his bachelor of arts from Vanderbilt University in 1901, where he played on both the baseball and football teams. Although he had an opportunity to join the Nashville Baseball Club soon after graduation, his father would not approve, and Rice soon began his long career as a sports journalist at the *Nashville Daily News* before moving over to the *Nashville Tennessean*.

Rice was the first to refer to a name change of the city's favorite baseball venue. Shortened to "Sulphur Dell" in subsequent columns, the name was struck forever as the designation for the ballpark. It was a good fit for a newspaper headline and had an acceptable flamboyance.

In February 1908, Rice held a contest with fans to give the Nashville Baseball Club an official team name, as usually the team was referred to as being under the tutelage of its current manager, such as the Fishermen (Newt Fisher), the Dobbers (Johnny Dobbs), and the Finnites (Michael Finn). No nickname had been officially recognized. Three names were selected from which voters could choose their favorite: "Rocks," "Lime Rocks," or "Volunteers." With the state capitol located near the ballpark and Tennessee being known as the Volunteer State, "Volunteers" was the logical choice and was often shortened to "Vols."

Throughout his career, Rice produced numerous books, poetry, and sports columns. He is probably best known by the quotation it is "not that you won or lost but how you played the Game," a quote from a poem he wrote for a *Tennessean* article in 1908 to describe a Vanderbilt alumnus football game.

In 1923, Rice did the play-by-play broadcasting for the first World Series game to be carried live on the radio. His friendships with Babe Ruth, Red Smith, Ring Lardner, Bobby Jones, and Jack Dempsey were a testament to his fairness in writing and his gentle spirit. He set the tone for American sports writing; Rice became most famous for naming the backfield of the 1924 Notre Dame football team the "Four Horsemen" and was known to his peers as the "Dean of American Sportswriters." He died on July 13, 1954, in New York City.

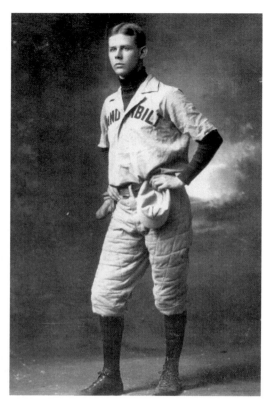

GRANTLAND RICE, VANDERBILT COMMODORE. In 1901, Rice graduated from Vanderbilt University in Nashville and was promptly offered an opportunity to join the Nashville Baseball Club in the Southern Association. His father disapproved, and he went on to become one of America's most beloved sportswriters. (Courtesy Vanderbilt University Archives.)

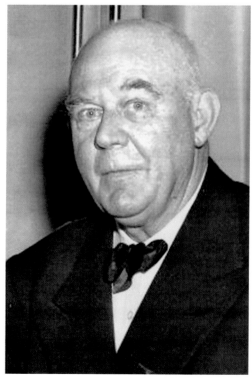

GRANTLAND RICE, SPORTSWRITER.
Grantland Rice gave Athletic Park the name Sulphur Dell during his time as a Nashville sportswriter. He also held a contest for fans to decide an official team name for the Nashville Baseball Club. One of Rice's typewriters is in the National Baseball Hall of Fame in a section devoted to sportswriters and broadcasters. (Associated Press Wirephoto.)

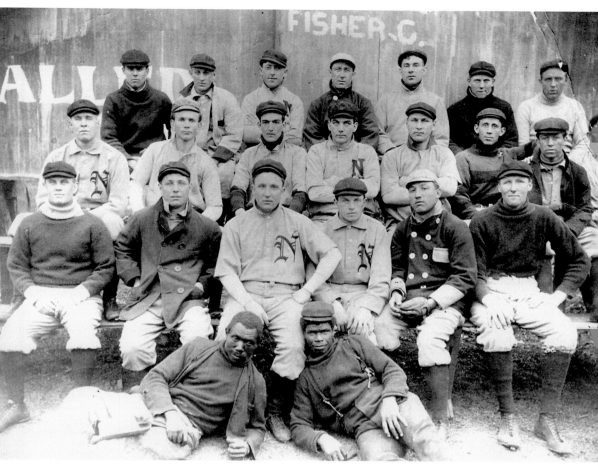

NASHVILLE BASEBALL CLUB, 1902. The 1902 team won a second Southern Association championship led by outfielder/pitcher Hugh Hill, who set the league record in 1902 for batting average in a season, hitting a controversial .416 while winning 22 games and losing 7 on the mound. His batting average set a standard never broken in the history of the league. The manager was Newt "Ike" Fisher, who was born in 1871 in Nashville. In 1898, he played for the Philadelphia Phillies but returned to Nashville in 1900 and was instrumental in the formation of the Southern Association in 1901. Fisher pitched in one game for the Nashville Tigers in the Southern League in 1893 and then played for Nashville from 1901 through 1903 before turning to strictly managing in the 1904 and 1905 seasons. (Courtesy Metropolitan Government Archives of Nashville and Davidson County.)

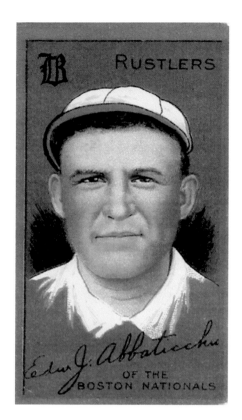

ED ABBATICCHIO. After breaking in with the Philadelphia Phillies in 1897 and before returning to the majors with Boston in 1905, Abbaticchio spent two seasons with the Nashville Baseball Club. In 1901, he scored 127 runs to lead the league, and in 1902, he stole 61 bases and had 18 triples while playing second base for the two-time pennant winners. (Author collection.)

JULIUS "DOC" WISEMAN. Playing for the first 11 years of Nashville's entry in the Southern Association, Wiseman was a steady outfielder who played in 1,401 games while tallying 1,248 hits. Although his best season was his first in 1901 when he batted .333, his Nashville career batting average was .260, and he never played major league baseball. (Author collection.)

THE GRANTLAND RICE ERA

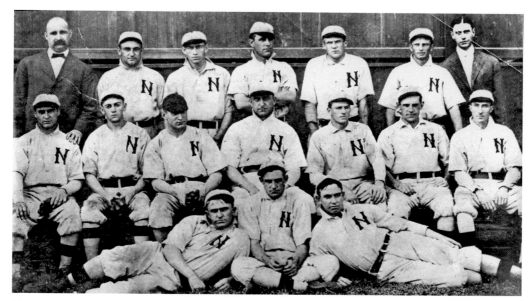

NASHVILLE VOLS, 1908. Beating New Orleans in the last game of the season, the Nashville Vols had over 10,000 fans crammed into Sulphur Dell for the game. The pitchers' duel between Pelicans lefthander Ted Breitenstein and Vols right-hander Vedder Sitton was settled in dramatic fashion as Nashville scored the game's only run with two outs in the bottom of the seventh inning for the Southern Association pennant. (Author collection.)

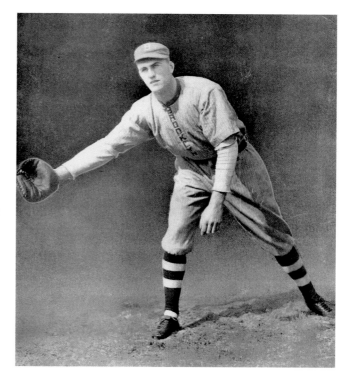

JAKE DAUBERT. Playing first base for the Nashville Vols in 1908, he shared the home run crown with six home runs. Signed by the Cleveland Indians at season's end, Daubert had stops with the Brooklyn Dodgers and Cincinnati Reds. After becoming ill late in the 1924 season, he died from complications following an appendectomy only a week earlier. He was 40 years old at the time of his death. (Author collection.)

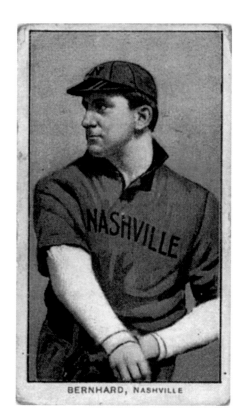

BERNHARD, NASHVILLE

BILL BERNHARD. On January 5, 1908, Bill Bernhard was named manager of the Nashville Baseball Club and promptly led the team to the Southern Association pennant, winning the championship on the last day of the season against the New Orleans Pelicans. His three-year managerial record for the Vols was 221-187. (Author collection.)

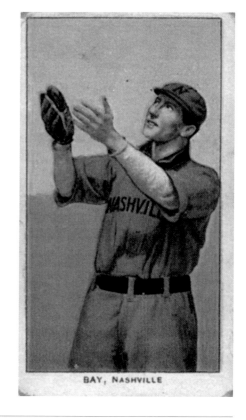

BAY, NASHVILLE

HARRY "DEER FOOT" BAY. Born in 1878 in Pontiac, Illinois, Bay spent eight seasons in the big leagues with the Cincinnati Reds from 1901 to 1902 and the Cleveland Indians from 1902 to 1908. He played in the outfield for four seasons with the Nashville Vols and was a member of the 1908 Southern Association championship team. (Author collection.)

THE GRANTLAND RICE ERA

Hubbard "Hub" Perdue. Born in Bethpage, Tennessee, Purdue was 28 years old when he broke into the major leagues in 1911 with the Boston Rustlers. Dubbed "the Gallatin Squash" by Grantland Rice during his playing days with the Nashville Baseball Club, Perdue won 16 games as a right-hander during the 1908 championship season. In 1909, he won 23 games and led the Southern Association in wins. (Author collection.)

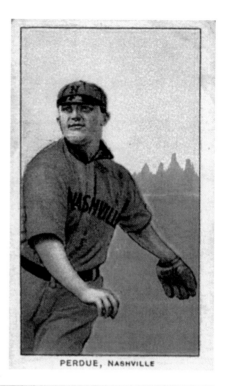

PERDUE, NASHVILLE

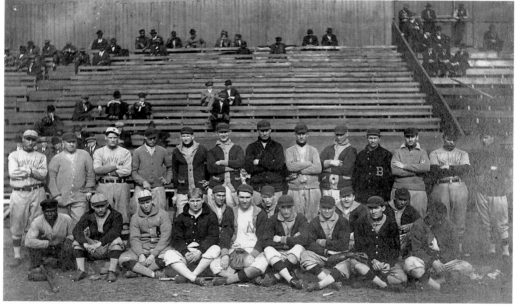

Nashville Vols, 1913. Manager Bill Schwartz also played first base as the 1913 Vols finished in seventh place with a 62-76 record. Pitchers Claude Williams (18-12) and Ernest Beck (17-12) won over half of the team's victories. The wooden stands of the original Sulphur Dell are seen in the background. (Author collection.)

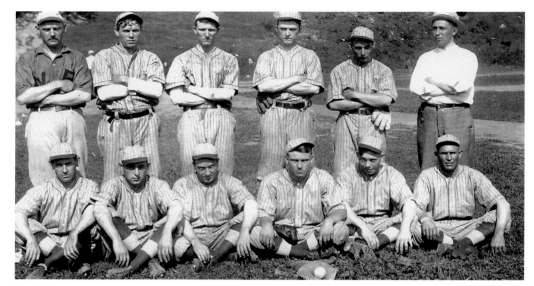

FIRE DEPARTMENT TEAM. Nashville's semi-professional and amateur teams were often formed within a business or government department. This photograph of the Nashville Fire Department team was most likely taken in 1916. The police department also organized their own team, and games were played at Sulphur Dell when the Vols were on road trips. (Courtesy Metropolitan Government Archives of Nashville and Davidson County.)

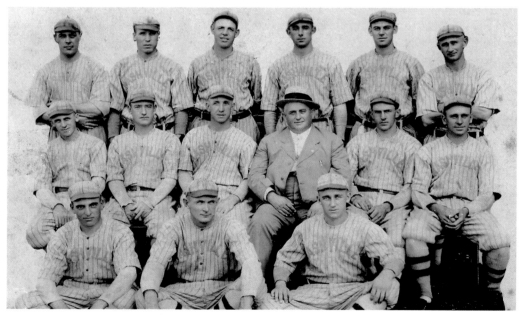

NASHVILLE VOLS, 1916. Led by pitcher Tom Rogers's 24 wins, the Vols won the 1916 Southern Association pennant by nine games over the New Orleans Pelicans. Rogers tallied 33 complete games out of 35 starts during the season, with Gus Williams leading the team at the plate with a .298 average. (Author collection.)

TOM ROGERS. On July 11, 1916, Tom Rogers threw a perfect game against the Chattanooga Lookouts at Sulphur Dell. Remarkably, the Vols had only one hit in the game against Lookout pitcher Jim "Lefty" Allen but won 2-0 as the Lookouts committed three errors and Allen hit one batter. Rogers finished the season with a 24-12 record. Sadly, only a few weeks earlier on June 18, Rogers struck Mobile batter Johnny Dodge in the head with a fastball. The 23-year-old Dodge died the next night. Rogers and Dodge had been teammates on the Nashville ball club the previous year. Besides Tom Rogers's perfect game in 1916, only two other Vols pitchers threw no-hitters up until that time. On September 19, 1908, during Nashville's championship season, Johnny Duggan won in Little Rock 1-0. Charlie Case no-hit New Orleans in Nashville on August 31 of the following year, also a 1-0 win. (Author collection.)

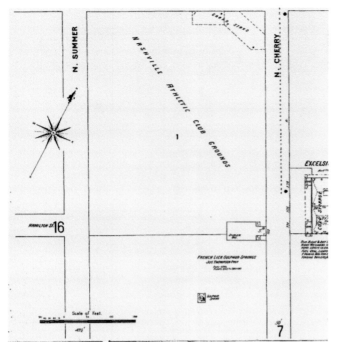

SULPHUR DELL, ORIGINAL LAYOUT. This drawing shows the layout of the ballpark in the second decade of the 20th century. The grandstand faced the state capitol to the southwest, and the natural sulphur spring is across the spur railroad track beyond left field. (Private collection.)

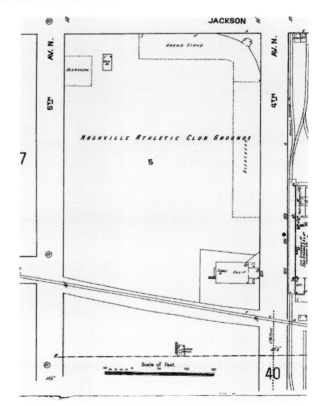

SULPHUR DELL, 1920. The original configuration of the ballpark remained the same through 1926, but the grandstands were expanded to handle the crowds for popular Nashville Vols afternoon games. (Private collection.)

THE GRANTLAND RICE ERA

ROY ELLAM. In 1916, Ellam became player-manager of the Nashville Vols and promptly led the team to the Southern Association title. He remained at the helm of the club through the 1920 season but played one year after that with the Mobile team before becoming manager of the Atlanta Crackers in 1922. (Author collection.)

WAITE HOYT. Before beginning his career in the majors, Waite "Schoolboy" Hoyt pitched for the Vols in 1918 and finished with a 5-10 record, leading the league with 16 complete games. One of only two former Nashville Vols to be elected to the Hall of Fame, once his baseball playing days were over, he became a popular radio announcer with the Cincinnati Reds. (Author collection.)

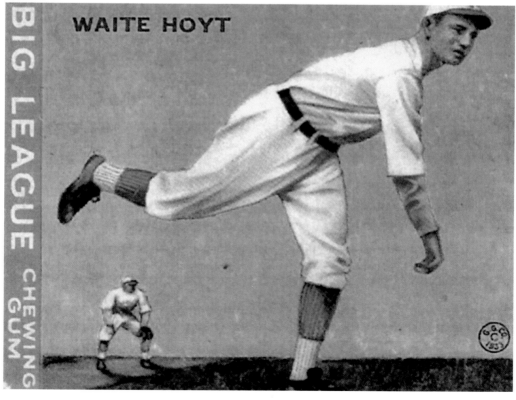

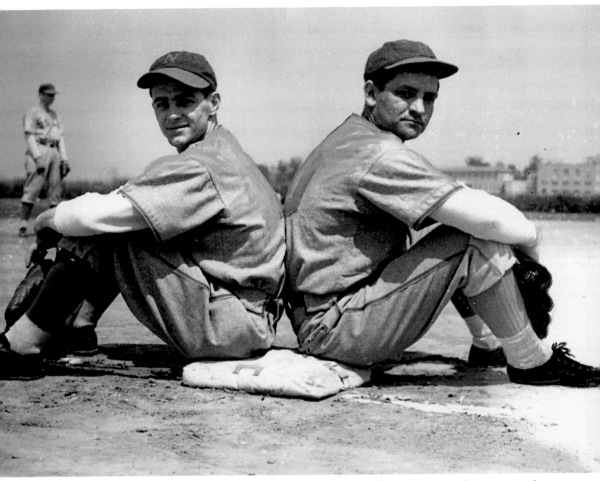

CLAUDE (LEFT) AND BUBBER JONNARD (RIGHT). Clarence "Bubber" Jonnard, who was a catcher, and his twin brother Claude Jonnard, a right-handed reliever, were born in Nashville and attended Tarbox School and Hume-Fogg High School. Claude joined the Nashville Vols in 1917, but not until 1919 when Clarence was called up to the club did they play on the same team. In 1920, Clarence Jonnard was one of the players to fill the Chicago White Sox roster after "Shoeless" Joe Jackson and seven of his teammates were indicted by a Chicago grand jury for the "Black Sox" scandal of 1919. "Bubber" became a chief scout of the New York Mets and was responsible for signing Ed Kranepool, Mike Jorgensen, and Ken Singleton. Claude was the National League's saves leader in 1922 and 1923. Although he did not play in the series, the 1922 Giants were World Series champions. (Courtesy Nashville Old Timers Baseball Association.)

3

SMALL CITY, BIG DREAMS

I was a fan of the Vols from June 1936 on (the first game I ever saw was when first baseman Jimmy Wasdell got his jaw broken by a pitched ball in 1936). We went to many a game on Saturday, riding the bus to the ball park and getting in free because it was children's day, buying a Pepsol and scorecard. I still have cinders in my knee from the time I slipped and fell in the cinder parking lot. The first time I saw another ballpark (Memphis), I wondered why it had a level right field!

—Annette Levy Ratkin, Nashville

Although popular players Clarence Jonnard, future Hall of Famer Kiki Cuyler, Axel Lindstrom, Benny Frey, Red Lucas, Fred Toney, Doug "Poco" Taitt, and Jim Poole would have seasons that would make them fan favorites, Nashville would not win another regular-season championship until 1940.

In 1929, Jim Poole finished the season with a .340 average, 33 home runs, and 127 RBIs but lost the Triple Crown as Birmingham's Art Weis had a better batting average of .345.

In mid-season of 1932, Charles "Chuck" Dressen came on board as manager. Led that year by Phil Weintraub's .401 batting average, the team won the first half of the Southern Association's split season but finished a woeful 12 games behind New Orleans in the second half. The Pelicans won the league pennant three games to one in the playoff to decide the championship.

Infielder Bill Rodda and Byron Speece were stalwarts on the Vols teams of the 1930s. Rodda stayed with Nashville from 1931 until 1939, and Speece joined the club in 1932. A right-handed pitcher, in 1934, he earned a 22-13 record while striking out 112 with a 2.99 ERA, but he topped that with a 22-9 record in 1936. He remained with the Vols and won 95 games from 1932 through 1937 for Nashville.

In 1934, Phil Weintraub had a .401 batting average for the season. Doug "Poco" Taitt, who had first joined the Vols in 1927 and spent a few seasons with the Atlanta Crackers, came back to the team in 1934 and the next year led the league in hitting with a .355 batting average.

Charlie Dressen returned to manage the Vols again 1938. His team was led by pitcher William Crouch's 21 wins and first-baseman Bert Haas's .338 batting average. Pitcher Ray Starr finished the season with a league-leading 20 losses.

In 1939, Larry Gilbert was hired as manager. Finishing in third place, Gilbert led his team to a four-games-to-three playoff victory over Atlanta for the chance to play Texas League champion Fort Worth. By taking four out of seven games in the Dixie Series, Gilbert began a winning tradition with Nashville that would see him build an 821-660 record as manager for the Vols.

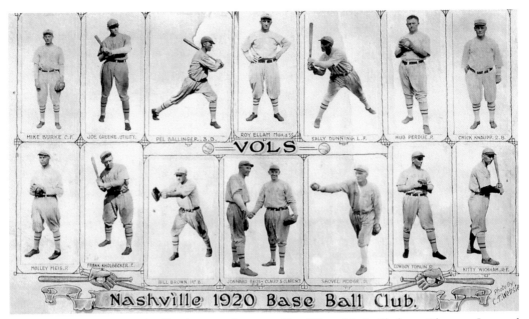

NASHVILLE VOLS, 1920. Led by shortstop/manager Roy Ellam, Nashville-born Clarence Jonnard caught 81 games for the Vols and pitcher Clarence Hodge won 17 games while losing 18. The team finished 26.5 games behind pennant-winner Little Rock. Ellam left the team at the end of the season but managed Atlanta in 1922. (Author collection.)

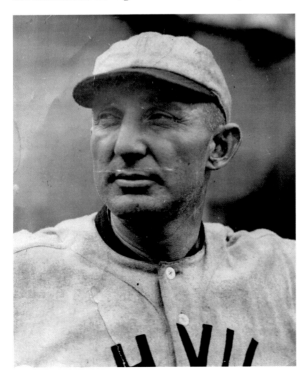

JIMMY HAMILTON. Hamilton managed the Nashville Vols from 1923 until being fired in the 1928 season. Although he had four winning seasons during his tenure, his teams never finished closer than third place. In 1925, shortstop Johnny Bates had a hitting streak of 46 games in which he amassed 72 hits. (Courtesy Lance Richbourg Jr.)

SMALL CITY, BIG DREAMS

HAZEN "KI-KI" CUYLER. One of two former Nashville Vols players to have been inducted into the National Baseball Hall of Fame, Hazen "Ki-Ki" Cuyler played in the outfield in 1923. He led the league with 68 stolen bases. Cuyler returned to the Southern Association to manage the Chattanooga Lookouts, Memphis Chicks, and Atlanta Crackers. (Author collection.)

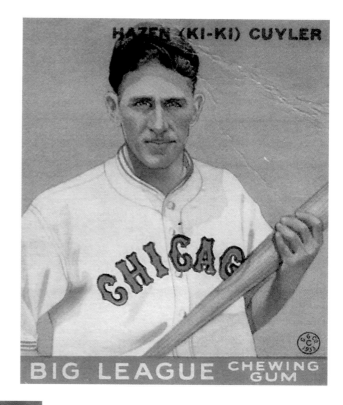

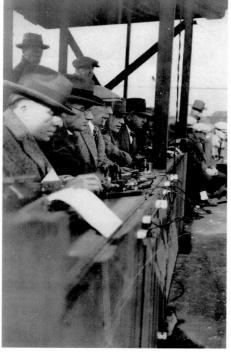

PRESS BOX AT SULPHUR DELL. Written on the reverse of this photograph is "Press Box on roof of Sulphur Dell park, Nashville, April 1, 1926, Jack Kieran, NY American (with pipe), Holmes, Brooklyn Eagle, George Monitor Daley, NY World." The year 1926 was the last year that the ballpark faced towards the southwest and the state capitol. (Author collection.)

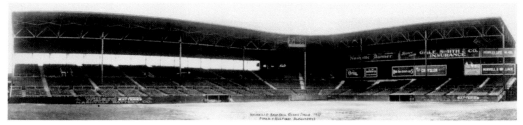

SULPHUR DELL GRANDSTAND. When the new ballpark was reconfigured and the grandstands were built, Nashville could boast of having one of the best concrete-and-steel stadiums in the South. With the new configuration, the Tennessee State Capitol loomed behind the stands. (Courtesy Roy Pardue.)

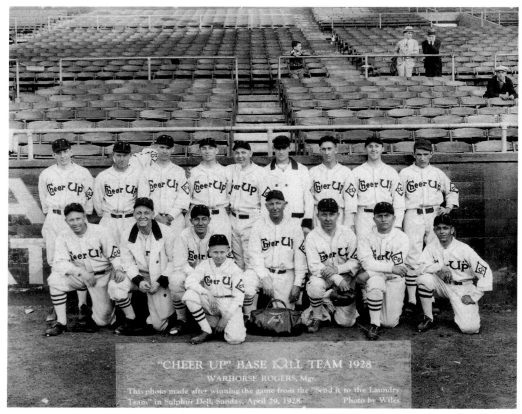

CHEER UP TEAM, 1928. One of the early amateur teams in Nashville, this team was organized and managed by Harry "War Horse" Rogers. Rogers was the organizer of the Nashville Old Timers Baseball Association, serving as the group's first president from 1939 until 1950. Sportswriter Fred Russell can be seen in the Sulphur Dell grandstand, leaning on the rail. (Courtesy Nashville Old Timers Baseball Association.)

SMALL CITY, BIG DREAMS

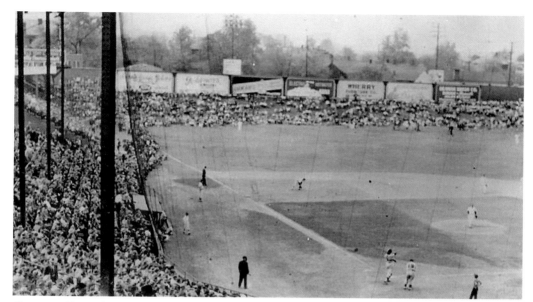

OPENING DAY, APRIL 12, 1932. A total of 14,502 fans greeted the Nashville Vols to begin the 1932 season. Since the seating capacity was 8,000 in the grandstands, the crowd sat on the outfield hills to view the game. The team would boast the league's best offense that year by batting .319, but even with the team's success, manager Joe Klugman was replaced by Chuck Dressen in July. (Courtesy Nashville Historical Society.)

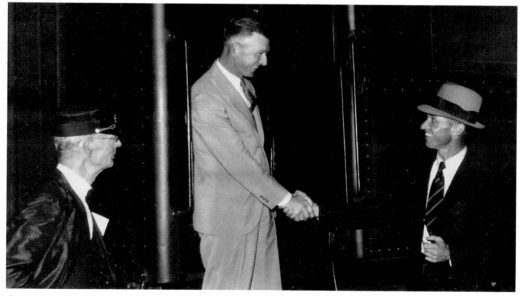

CHARLES DRESSEN AND LANCE RICHBOURG. "Chuck" Dressen served two stints as field leader of the Nashville Vols. Leaving Nashville to manage the Cincinnati Reds in 1934, his replacement, Lance Richbourg, bids him well as Dressen boards the northbound train. Dressen returned to manage Nashville again in 1938. (Author collection.)

BASEBALL IN NASHVILLE

BILL RODDA. Rodda was a stalwart infielder for the Nashville Vols from 1931 to 1938 and was hired by Larry Gilbert as a player/coach in 1939. The popular Rodda became manager of the Anniston Rams in the Southeastern League in 1940. (Courtesy Ken Knudson.)

NASHVILLE VOLS, 1937. Willie Duke hammered a league-leading 19 home runs for Nashville as the team, led by manager Lance Richbourg, finished 17 and a half games behind the Little Rock Travelers. Ray Starr was the ace of the pitching staff with a 19-12 record in 276 innings. (Author collection.)

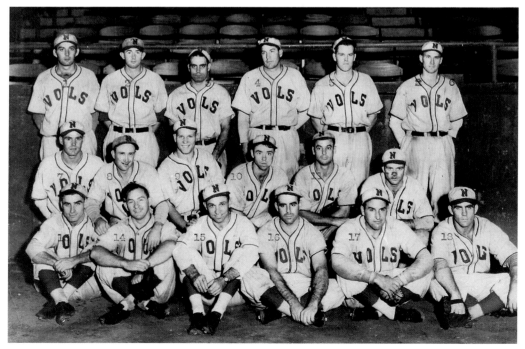

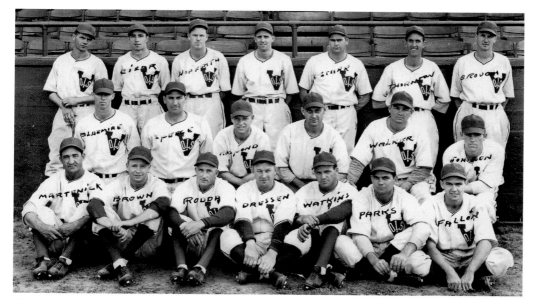

NASHVILLE VOLS, 1938. "Chuck" Dressen returned to Nashville to manage the Vols to a second-place finish behind the Atlanta Crackers in the Southern Association race. William Crouch (third row, far right) led the league in wins with 28, and Ray Starr (third row, third from right) led the league in losses with 20. Larry Gilbert would take over the managerial reins in 1939. (Author collection.)

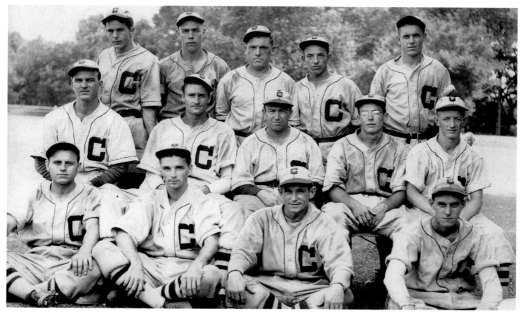

CARTER SHOE BASEBALL TEAM. One of the many local amateur teams, Carter Shoe included among its team members Julian "Junie" McBride (first row, far right). McBride was a catcher on the City League team. (Courtesy Junie McBride.)

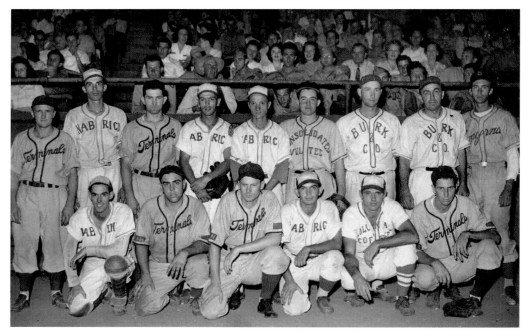

CITY LEAGUE ALL STARS. Representing amateur teams Terminal, Consolidated Vultee, Nashville Bridge Company, and Burke and Company, the All Star team members included Bubber Murphree, Ollie Frith, Paul Hasty, Mutt Quillen, Hayes Pierce, "Junie" McBride, Charles Cummins, Everett Green, and Chet White. (Courtesy Junie McBride.)

CENTENNIAL PARK. One of the most centrally located ballparks in the city was Centennial Park, near Vanderbilt University and West End Avenue. The Parthenon and other exhibits were built in another area of the park for Tennessee's Centennial Exhibition. It was not unusual for 7,000 fans to show up for a Saturday or Sunday afternoon game between amateur teams. (Courtesy Nashville Old Timers Baseball Association.)

SMALL CITY, BIG DREAMS

4

NEGRO LEAGUE BASEBALL

*Each day we read in the papers long articles about the beginning of the baseball season and about
what the different league teams are doing. I do not think it would be out of place to mention
a few facts about the Negro teams and what they are doing. It is true that Nashville has been
a bit slow in past seasons in baseball. I do not mean that there has not been good baseball
players in Nashville for no town in the South can furnish more good baseball material than
Nashville. But it has not been gotten together and handled as it should have been, however,
it is of the present and future not of the past about which we wish to talk. The season of 1911
from all indications is going to be the greatest in the history of Nashville for Negro baseball.*

—*Nashville Globe*, March 10, 1911

The Nashville Standard Giants, Methodist Publishing House, North Nashville Tigers, and the
Baptist Printers were Negro teams organized in the early 1900s. Players of note were Walter
Campbell, Henry O'Neal, Joe Bills, Haywood Rhodes, and Blaine Boyd. Visits by traveling Negro
League teams to challenge the best local teams were not uncommon, and Fisk and Pearl High
were playing baseball schedules on a regular basis.

In 1933, the resurrected Negro National League accepted Tom Wilson's Elite Giants as a
member and Wilson built his own park, Wilson Park, for his team. Wilson Park was often used
as a practice field by other Negro League teams for spring training. Roy Campanella says in his
autobiography, *It's Good to Be Alive*:

> Training in Nashville, or anyplace else with the Elites, was nothing like my Dodger days at
> Vero Beach. In the big leagues the first week and more is spent pretty much just loosening
> the winter kinks and getting your arms and legs in shape. But that's not how it was, ever,
> in the Negro Leagues. No sooner did you pull on your uniform than you were in a game,
> playing before paying customers.

Negro League players Norman "Turkey" Stearnes, Henry Kimbro, Clinton "Butch" McCord,
and Sidney Bunch called Nashville their home. After joining the Chicago American Giants
in 1932, Stearnes played in the inaugural East-West All Star Game in 1933. Henry Kimbro was
born in Nashville in 1912 and retired to his own business in his hometown after compiling a
.315 lifetime batting average.

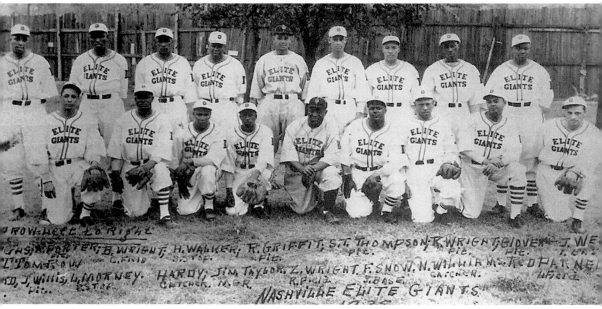

Nashville Elite Giants, 1935. In 1920, Tom T. Wilson chartered the Nashville Standard Giants semi-professional team. In 1931, his team gained entry into the Negro National League. Although the league disbanded that year, another opportunity arose in 1933 for him to place a team in the resurrected Negro National League. He renamed his team the Nashville Elite Giants. (Courtesy National Baseball Hall of Fame Library, Cooperstown, New York.)

ELLIS (FIRST NAME UNKNOWN), NASHVILLE ELITE GIANTS. Negro League baseball was a part of the Nashville sports landscape in the early 20th century. Ellis was a first baseman for the 1921 Elite Giants. (Courtesy Nashville Globe Rotogravure and Pictorial Section.)

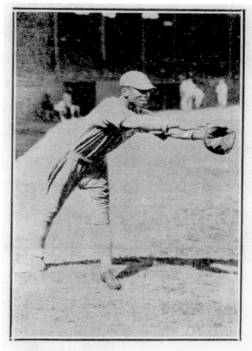

Ellis, first baseman for Elite Giants.

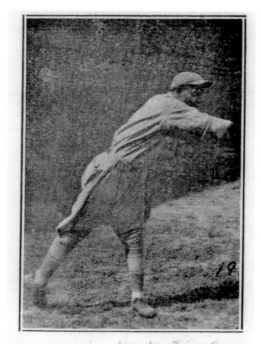

Thomas, pitcher for the Elite Giants.

THOMAS (FIRST NAME UNKNOWN), PITCHER, NASHVILLE ELITE GIANTS. Nashville's Thomas T. Wilson took over the Nashville Standard Giants in 1918. On March 26, 1920, Wilson chartered the Nashville Standard Giants as a semi-professional baseball team and played "all-comers," including white-only teams. (Courtesy Nashville Globe Rotogravure and Pictorial Section.)

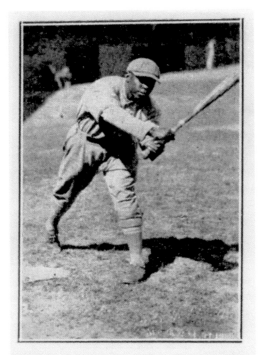

Phillips, short stop for Elite Giants.

PHILLIPS (FIRST NAME UNKNOWN), NASHVILLE ELITE GIANTS. Nashville's most famous Negro League team built a reputation throughout the region, and the Standard Giants became one of the most influential clubs to play for as the team's success and popularity grew. In 1921, Phillips was a shortstop for the renamed Elite Giants. (Courtesy Nashville Globe Rotogravure and Pictorial Section.)

EDDIE NOEL, NASHVILLE ELITE GIANTS. Noel was a pitcher for the "Elites" in 1921. The local team was member of the Negro Southern League, consisting of teams in Nashville, Atlanta, New Orleans, Memphis, Montgomery, and Birmingham. (Courtesy Nashville Globe Rotogravure and Pictorial Section.)

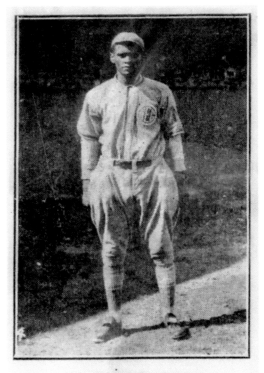

MR. EDDIE NOEL

"Turkey" Stearnes. Norman Thomas "Turkey" Stearnes was a native Nashvillian and was inducted into the National Baseball Hall of Fame in 2000. Stearnes began his career in Nashville in 1920 and later played 10 seasons for the Detroit Stars in the Negro National League. Noted as a prolific home run hitter, it was reported that in 585 games, he hit 144 home runs. (Author collection.)

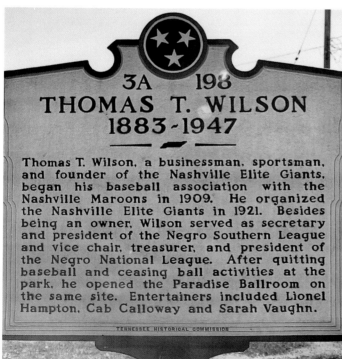

3A 198
THOMAS T. WILSON
1883-1947

Thomas T. Wilson, a businessman, sportsman, and founder of the Nashville Elite Giants, began his baseball association with the Nashville Maroons in 1909. He organized the Nashville Elite Giants in 1921. Besides being an owner, Wilson served as secretary and president of the Negro Southern League and vice chair, treasurer, and president of the Negro National League. After quitting baseball and ceasing ball activities at the park, he opened the Paradise Ballroom on the same site. Entertainers included Lionel Hampton, Cab Calloway and Sarah Vaughn.

TENNESSEE HISTORICAL COMMISSION

Tom Wilson Park. Wilson Park, an 8,000-seat stadium, was constructed in the middle of Nashville's largest black community. Tom Wilson owned the Nashville Elite Giants and was a well-known promoter of his team. Tom Wilson Park was often used by the Nashville Vols, and many times pre-season games were held with the Elite Giants. (Author collection.)

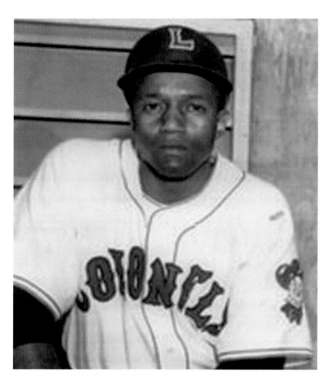

CLINTON "BUTCH" McCORD. Becoming the first player ever to be awarded the Silver Glove two years in a row, McCord's distinguished career included stints with the Nashville Cubs, Baltimore Elite Giants, and minor-league clubs in Paris, Illinois, Denver, Richmond, Columbus, Louisville, Macon, and Victoria, Texas. Born in Nashville, Tennessee, the ball field at Tennessee State University is named in his honor. (Courtesy Clinton "Butch" McCord.)

SIDNEY BUNCH. "Sid" Bunch played for the Birmingham Black Barons. He was signed by the Brooklyn Dodgers organization and sent to Billings, Montana. After his retirement from playing in the minors, Bunch spent two seasons in the Canadian Football League with the British Columbia Lions. (Courtesy Mickey Holton.)

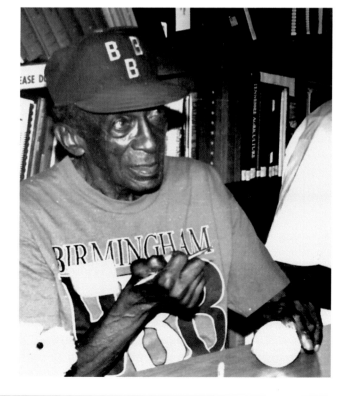

5

SULPHUR DELL

*The name stuck with the locals, just as baseball had four decades earlier. (The irony
that didn't go unnoticed was that this "dell"—the term for a tree-lined valley—was
largely a coal-smoke-filled, flooding lowland. Part of it was even used as a city dump, its
fires often sending out acrid fumes.) Many in the early days used the streetcar to get to
and from games. A line of parked streetcars awaited the "wild scramble" of fans after
the last out . . . seats in the initial grandstand were slatted wood with armrests.*

—George Zepp, *The Tennessean*

Located between what are now Fourth and Fifth Avenues, Jackson Street, and a railroad spur just north of downtown Nashville, the low-lying area known as Athletic Park and Sulphur Dell had an unusual outfield contour and was prone to flooding when the banks of the nearby Cumberland River rose during spring rains.

The field was often described as looking like a "drained-out washtub." Babe Ruth once declared that he wouldn't play on anything a cow couldn't graze on before an exhibition game between the hometown Vols and the New York Yankees.

Many managers referred to Sulphur Dell as "Suffer Hell," as the park gave many visiting ballplayers headaches trying to navigate the hill. Often the second baseman could retrieve a hard line drive that bounded off the short right-field fence and throw the batter out at first.

Players on Nashville's teams usually learned the idiosyncrasies of the playing field, but not always. In 1934, Vols right fielder Phil Weintraub ran down the "dump" attempting to field a grounder and it rolled through his legs. Weintraub retrieved the ball at the top of the hill but dropped it and it rolled back down the incline. Once he caught up to the ball again, his throw to third was high into the grandstands and the Vols outfielder was charged with three errors on one play. The batter scored on what should have only been a single.

The wooden outfield fence was 16 feet high, and in 1931, a 186-foot-long, 30-foot-tall screen was placed atop the outfield fence from the right field foul pole to right-center. With bleachers down the left-field line, the ballpark held 7,800 spectators. The proximity to the city dump, a stockyard, and meat-packing plant earned the park the nickname "the Dump."

Following the 1961 baseball season, the "Dell" sat silent for a year before once again Nashville fielded a team, this time in the South Atlantic League. The year 1963 would be the last year for professional baseball in Sulphur Dell as it was sold and turned into a racetrack. When racing failed, the park was used as a city tow-in lot before finally being razed in 1969 and turned into a parking lot.

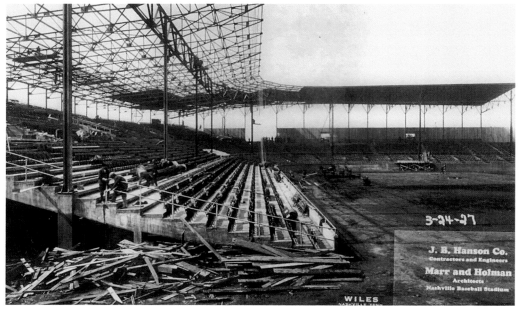

BALLPARK CONSTRUCTION. Hitters faced the southwest and the Tennessee State Capitol until 1927, when the old grandstands were demolished and the playing field was turned around so that the setting sun would not be a problem for batters. In 1951, Fred Russell, sportswriter for the *Nashville Banner*, reported that the old base paths from the original configuration could still be seen from the press box. This dated view does not reveal that the Vols played their first game two days later, an exhibition game against the Minneapolis Millers. The concrete-and-steel grandstands were built with a seating capacity of 7,000, but it was increased to 8,500 in 1938. (Courtesy Tennessee State Archives.)

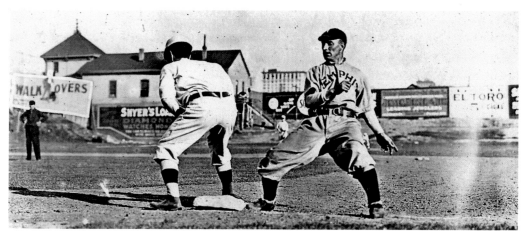

PRE-1927 FIELD VIEW. This view is undated but shows a clear image of Sulphur Dell during a play at first base by two unidentified players. The field was turned around in the opposite direction in time for the 1927 season, so this photograph was taken during a game before the ballpark was changed. (Author collection.)

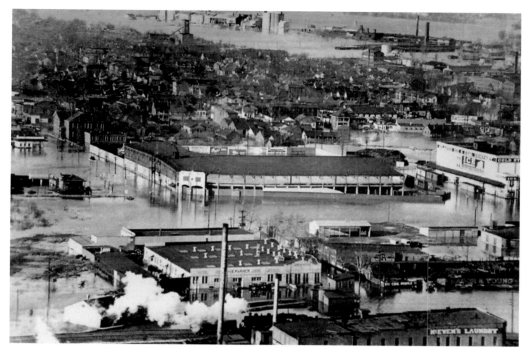

PRONE TO SPRING FLOODING. When the nearby Cumberland River would overrun its banks, the low land that included Sulphur Dell would flood. Often when the Vols returned from spring training, the field would be too wet once the waters receded and games in the early season would be postponed. (Courtesy Metro Government Archives of Nashville and Davidson County.)

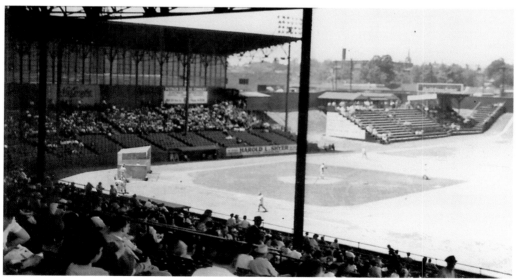

LEFT FIELD LINE. Third base was only 26 feet from the grandstands, giving fans a close view of the action on the field. The distance down the left field line was 334 feet to the outfield wall. (Author collection.)

BASEBALL IN NASHVILLE

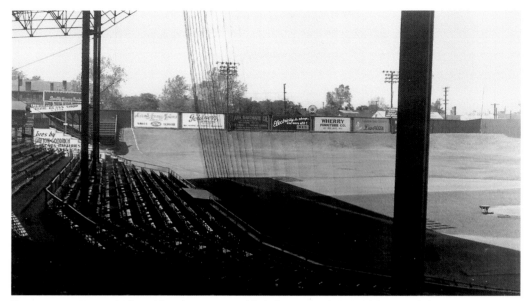

BLEACHERS VIEW. When bleachers were added down the left field line, Sulphur Dell's seating capacity was increased to 8,500. Bleachers on the hill in foul territory were for Nashville's black community. (Author collection.)

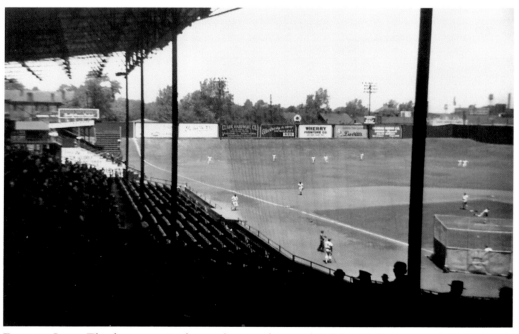

DEEP TO LEFT. The first game in the newly turned-around Sulphur Dell was an exhibition game played against the Minneapolis Millers of the American Association on March 25, 1927. Minneapolis right fielder Dick Loftus hit the first home run in the new configuration. (Author collection.)

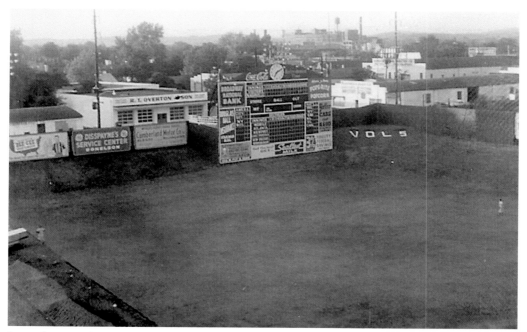

LEFT-CENTER SCOREBOARD. When the manually operated scoreboard was added in left-center field, it gave another dimension to balls hit to the outfield. Outfielders learned to play the angles of balls that bounded off the giant structure. The distance to the center field corner was 421 feet from home plate. (Author collection.)

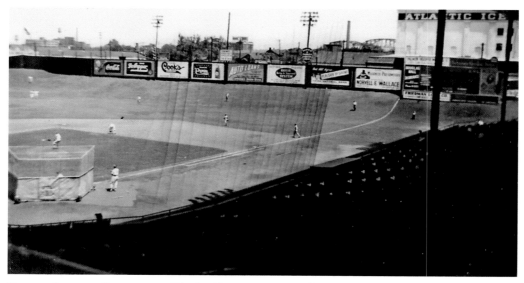

RIGHT CENTER. Sportswriter Blinky Horn, writing in the *Nashville Tennessean* about the first game in 1927, referred to right field as the "right center dump," calling attention to the unusual design of the ballpark and acknowledging the smell that the nearby city dump offered to the lingering odor in the air. (Author collection.)

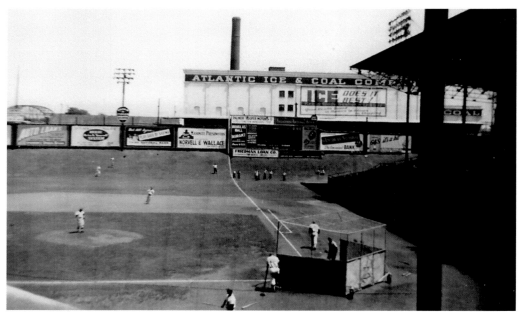

RIGHT FIELD. The entire playing surface at Sulphur Dell was below street level. In right field, a 10-foot shelf 230 feet from home plate caused the name "mountain goat" to be given to right-fielders who navigated the steep outfield beyond second base. If a player was standing against the bottom of the right field fence, he stood 22.5 feet above the playing field. (Author collection.)

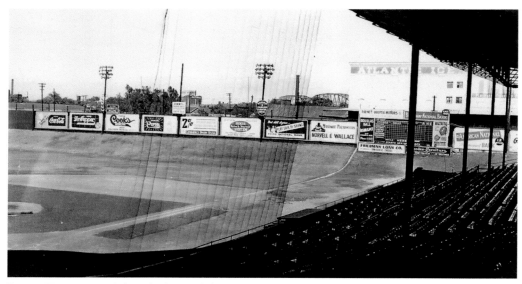

RIGHT FIELD LINE. John Black, pinch-hitting for the pitcher in the fourth inning of an exhibition game against the Milwaukee Brewers, hit a home run on April 1, 1927, to become the first Nashville player to hit one over the fence in the new Sulphur Dell. First base was 42 feet from the stands, and the distance down the right field line was 262 feet. (Author collection.)

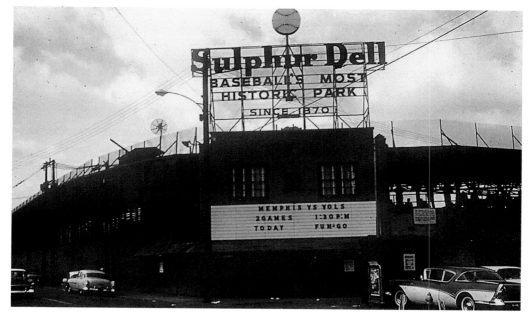

ENTRANCE TO SULPHUR DELL. Bordered by what are now Fourth Avenue, Fifth Avenue, Jackson Street, and a spur railroad track, the ballpark was dubbed "Sulphur Dell" by Grantland Rice while he worked as a sports reporter for the *Nashville Tennessean*. The large sign overlooking the entrance to the park was a landmark for many years. It was erected in the 1950s. (Courtesy Metropolitan Government Archives of Nashville and Davidson County.)

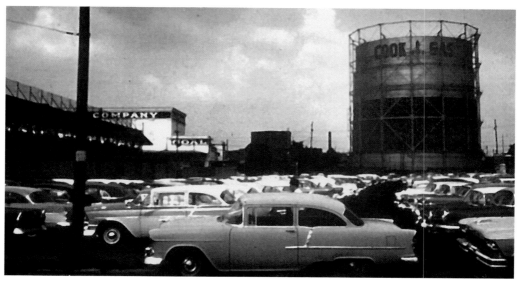

COOK GAS TANK. The tank was a fixture outside of Sulphur Dell near the parking lot on the first base side of Sulphur Dell. Also visible is the Atlantic Coal and Ice House, which sat on the opposite side of Fourth Avenue beyond the right field fence. (Courtesy Metropolitan Government Archives of Nashville and Davidson County.)

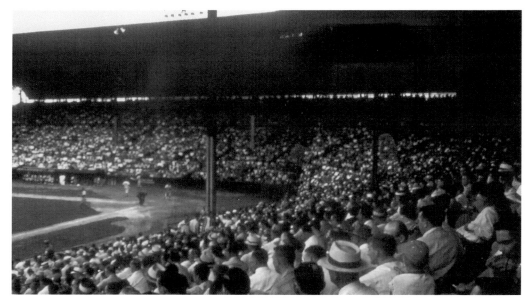

FULL HOUSE. Sulphur Dell and the Nashville Vols were crowd favorites, and a sunny afternoon was a great time to take in a ball game. The seats in the grandstand were painted ballpark green, except for the reserved section, which was painted orange. (Courtesy Metropolitan Government Archives of Nashville and Davidson County.)

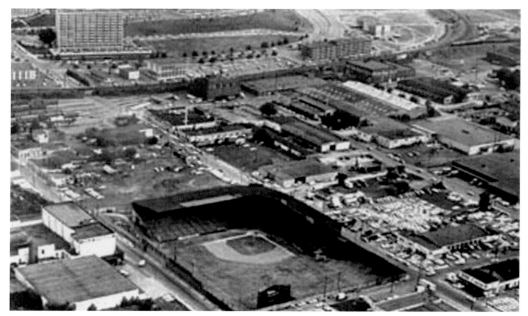

AERIAL VIEW. Batters had their backs to the state capitol, and outfielders would battle the sun until late afternoon during day games. James Robertson Parkway is in the background, and the odd dimensions of Sulphur Dell are easily visible from the air. The area is now a parking lot and walkway. (Courtesy Nashville Old Timers Baseball Association.)

THE LARRY GILBERT
YEARS

Make winning so pleasant and losing so unpleasant that hustle is automatic.

—Larry Gilbert

Born in New Orleans, Larry Gilbert pitched for Victoria in 1910, where his record was 18-6. After becoming an outfielder in 1911 with Battle Creek, he still pitched enough to win 18 games for the team. With Milwaukee in 1913 as a centerfielder, he was drafted by Boston and played on the 1914 "Miracle" Braves team under George Stallings, former manager in Nashville. After spending part of the 1915 season with Boston, Gilbert finished the year with Toronto but would not report the following season. Gilbert was purchased by New Orleans and, in 1919, led the Southern Association with a .349 batting average and 42 stolen bases. He retired as a player following the 1925 season but continued as manager.

In 1939, after five league championships and 15 seasons with New Orleans, Gilbert joined Nashville Vols as manager and co-owner. He promptly led the team to their first of four Shaughnessy Playoff championships in a row and took the Dixie Series titles in 1940, 1941, and 1942. He was named Outstanding Minor League Leader by the *Sporting News* in 1940.

During his minor-league managerial career, Gilbert won nine championships. His record ranks high in minor-league history with 2,128 wins and 1,628 losses, and his Nashville teams were in the playoffs eight times during his 10 years, with a playoff record of 66-33.

His son Charlie played in the majors before playing for his father in Nashville in 1948. He hit seven home runs in the first four games of the 1948 season to set a league record for most homers in consecutive games. In his last at-bat on April 21, the ball hit the top of the fence and bounded back inside the park. Charlie batted .362 and led the league with 178 runs and 155 walks and later joined his father in the Vols front office.

Larry's youngest son, Harold "Tookie" Gilbert, led the Southern Association in 1949 for the Vols with 146 runs and 197 hits as the team won the pennant under manager Rollie Hemsley. Larry Gilbert Jr., oldest son of the famous minor-league manager, passed away in August 1941 in Nashville.

Larry Gilbert moved to Nashville's front office in 1949, remaining there until selling his stock in the club to Ted Murray. Gilbert died in New Orleans in 1965 at the age of 73.

LARRY GILBERT. The most successful manager in the Southern Association, Larry Gilbert won nine pennants. From 1939 through 1948, he led the Nashville Vols after managing the New Orleans Pelicans for 16 years. He appeared in 72 games with Boston's "Miracle" Braves, batting .268 in 1914. He returned to Boston in 1915 and batted .151 while playing in 45 games. (Courtesy Metropolitan Government Archives of Nashville and Davidson County.)

FAY MURRAY. Fay Murray pulled off the biggest coup in Southern Association history by hiring Larry Gilbert away from the New Orleans Pelicans. After witnessing the 1940 Vols championship season, the popular team owner passed away on March 4, 1941. Loved by his staff, players, sportswriters, and fans, this avid horseman left a lasting legacy in Nashville sports history. (*Vol Feats, Nashville Banner.*)

NASHVILLE BASE BALL CLUB

SOUTHERN LEAGUE

NASHVILLE, TENNESSEE

New Orleans, La.
Nov. 28, 1938.

Dear Frank,

Received your letter about calendar, will see you at
the meeting next week,

It will seem funny seeing me in Nashville, but I think
everything will work out alright.

Hope that you and Josephine are enjoying yourselves
out in the country.

With kindest personal regards,

Sincerely

Larry Gilbert.

LARRY GILBERT LETTER. Soon after being signed by Fay Murray as manager and becoming co-owner of the Vols in 1938, Gilbert went right to work. This letter is to Memphis Chicks general manager Frank Longinotti, written on November 28 from Gilbert's home in New Orleans. (Author collection.)

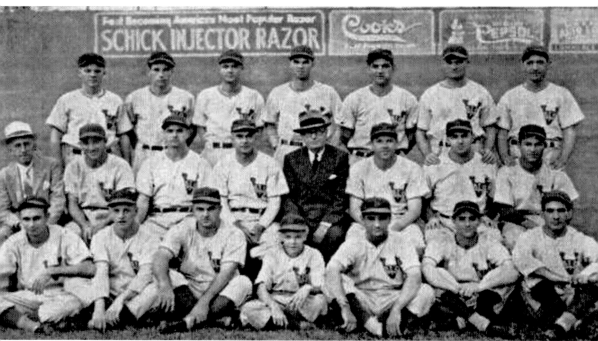

NASHVILLE VOLS, 1940. In conjunction with its 100th-anniversary celebration in 2001, Minor League Baseball named the 1940 Nashville Vols as the 47th best minor-league team of all time. Included on the roster were Cletus "Boots" Poffenburger, Tom Drake, John Milhalic, Oris Hockett, Gus Dugas, George Jeffcoat, Ace Adams, Russ Meers, Dick Culler, Charley "Greek" George, Mickey Rocco, Robert Boken, Arnold Moser, Johnny Sain, Tommy Tatum, Marv Felderman, and Leo Twardy. After leading the league from opening day until season's end, Larry Gilbert's team won 101 games. The team's batting average totaled .311 for the year, Boots Poffenberger won 26 games, and reliever Ace Adams stuck out 122 rival batters. George Jeffcoat struck out 18 Chattanooga Lookouts on September 10, 1940, in a Shaughnessy Playoff game for Nashville at the end of the season. The Vols beat Houston of the Texas League four games to one in the Dixie Series. Ironically, the team roster stayed intact for the entire season. (Author collection.)

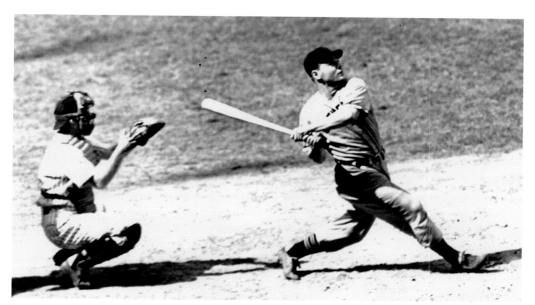

LES FLEMING. Thick-wristed Les Fleming was a first baseman for the Vols in 1941, and in 106 games, he batted .414, just missing the league record set in 1902 by Hugh Hill. In the first 13 games of the season, Fleming hit 10 home runs. In this photograph, he is batting for the Cleveland Indians in 1942. (Acme Photograph.)

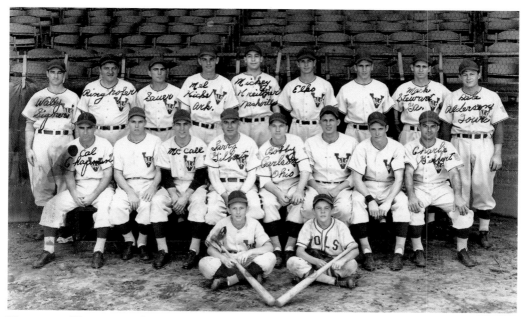

NASHVILLE VOLS, 1943. Once again, Larry Gilbert's team won the Southern Association crown by beating Shreveport in the split-season playoff series four games to two. Ed Sauer had an exemplary year with a league-leading .368 batting average, scoring 113 runs, hitting 51 doubles, and stealing 30 bases. (Charles Renegar photograph.)

BASEBALL IN NASHVILLE

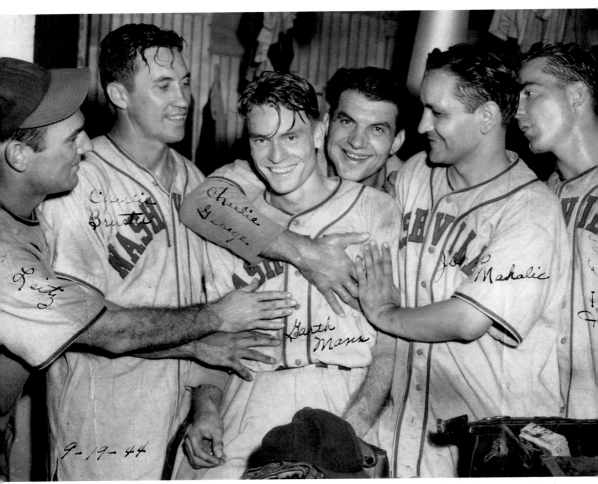

NASHVILLE TEAM CONGRATULATIONS. From left to right, Al Leitz, Charlie Brewster, Garth Mann, Charlie "Greek" George, John Milhalic, and Pete Elko celebrate a victory on September 19, 1944. Mann would finish the season with a 7-7 mark. The team finished in third place with a 79-61 record, seven and a half games out of first place. (Author collection.)

MICKEY KREITNER. Kreitner was a steady catcher for the Vols on the Southern Association championship team in 1943. Called up by the Chicago Cubs at the end of the season, he made his major-league debut on September 28, 1943, in a doubleheader against the New York Giants at Wrigley Field. Kreitner died in his hometown of Nashville at the age of 80. (Author collection.)

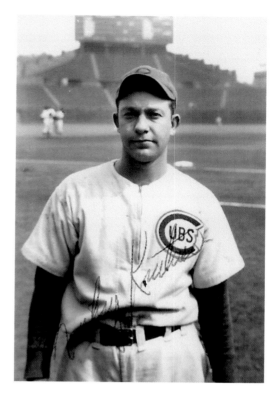

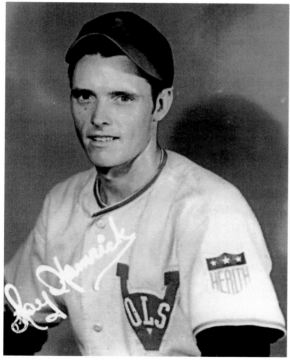

RAY HAMRICK. A talented shortstop, Hamrick batted for a .310 average on 145 hits while playing on the 1943 championship team. He broke into the major leagues with an August call-up to the Philadelphia Phillies. (Courtesy Tony Roberts.)

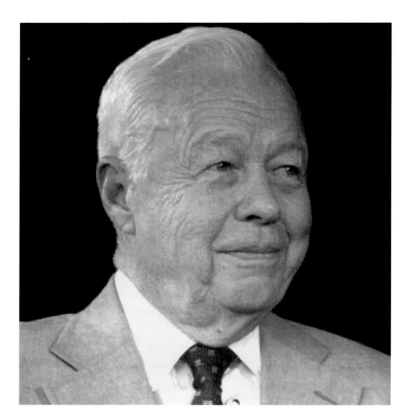

LEE MACPHAIL. Leland Stanford MacPhail Jr. was born in Nashville. MacPhail spent 45 years in organized baseball with the New York Yankees and Baltimore Orioles and was also chief aide to Commissioner William Eckert and president of the American League. Elected to the Baseball Hall of Fame in 1998, he joined his father, Larry MacPhail, as the only father and son members. (Courtesy Nashville Old Timers Baseball Association.)

NORTH HIGH AT SULPHUR DELL. In 1945, North High School had among its players future Nashville police chief Joe Casey (second row, far left). Managed by Hickman Duncan (first row, far left), the author's father, Virgil Nipper, is seated next to Duncan. Although there were no state championships at that time, North won the Nashville Interscholastic League championship. (Courtesy Virgil Nipper.)

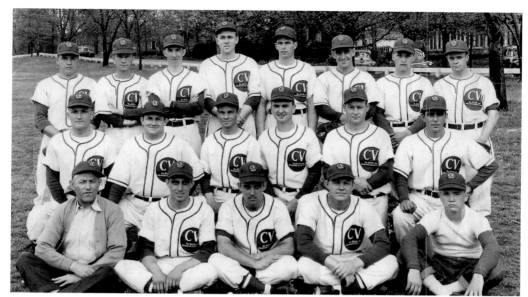

CHAMPAGNE VELVET TEAM. This team was one of many that were organized thanks to the popularity of baseball in Nashville. Playing games at Morgan Park, Centennial Park, Shelby Park, and Sulphur Dell, this team was sponsored by a beer brand. The photograph was taken at Centennial Park. (Courtesy Nashville Old Timers Baseball Association.)

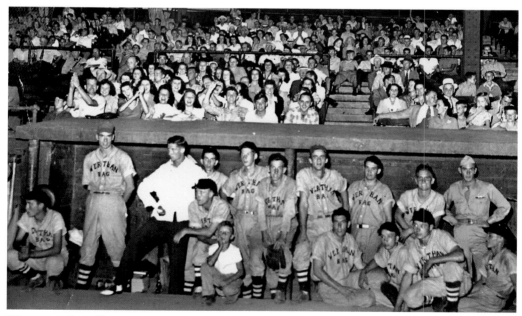

WERTHAN BAG TEAM, 1945. The Werthan Bag team played the Larry Gilbert League All Stars at Sulphur Dell in 1945. The league was named after the popular Nashville manager. Other team sponsors were Nashville Bridge Company, Cook's Beer, Burke and Company, Moose Lodge, North Nashville Merchants, Shaft Movers, Falstaff Beer, and Shyer Jewelers. (Courtesy Lindy Freeman.)

BASEBALL IN NASHVILLE

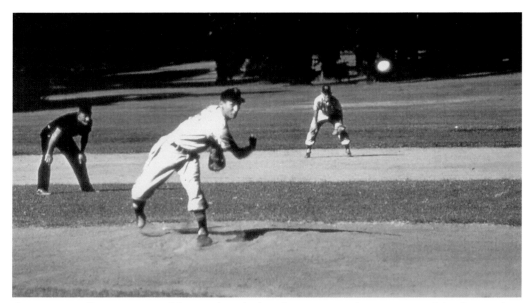

CENTENNIAL PARK ACTION. This unidentified pitcher's team is playing at one of the diamonds at Centennial Park, a favorite venue because of its central location. Vanderbilt University is nearby on West End Avenue. There were no fences at any of the city ballparks. (Courtesy Metropolitan Government Archives of Nashville and Davidson County.)

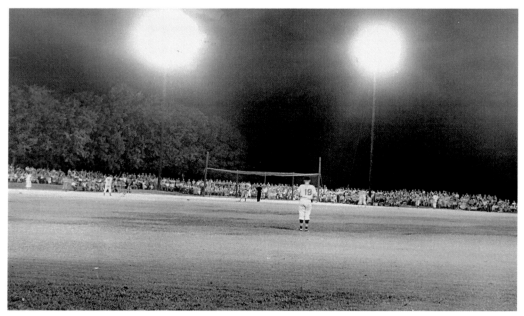

LIGHTS AT CENTENNIAL PARK. When lights were added to the baseball diamonds at Centennial Park, it allowed for more games to be scheduled and more participants to play in local leagues. High school, Larry Gilbert, Capital City, and Tri-state League games showed great fan support. (Courtesy Nashville Old Timers Baseball Association.)

LARRY GILBERT LEAGUE. The amateur league named for the Nashville Vols manager consisted of players up to 19 years of age. Gilbert is shown (right) attending one of the league's All Star games at Sulphur Dell. In the 1940s, it was not unusual for the ballpark to be filled with over 7,000 spectators to watch a game in the amateur league. (Author collection.)

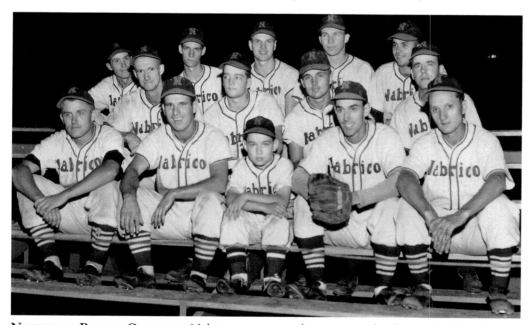

NASHVILLE BRIDGE COMPANY. Nabrico was a popular team to play for in the City League. Although the paying of players was forbidden in the amateur league, it was not unusual for sponsors to provide employment for players on the team. Former major-leaguer George Archie is on the second row, far left. (Courtesy Nashville Old Timers Baseball Association.)

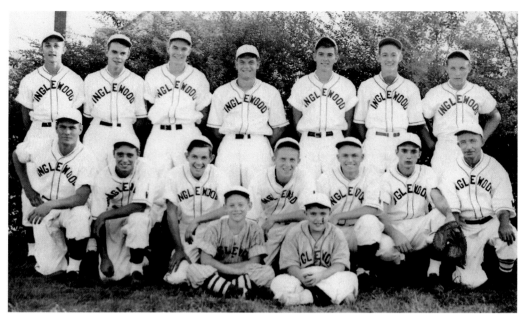

YOUTH LEAGUE BASEBALL. Many youth leagues were organized in Nashville for boys to play baseball, and team sponsorships were an important part of keeping the leagues up and running. "Tookie" Gilbert (second row, third from left), youngest son of the Nashville Vols manager Larry Gilbert, played for the Inglewood team. (Courtesy Nashville Public Library, the Nashville Room.)

HAL JEFFCOAT, 1947. The brother of former major-league pitcher George Jeffcoat, Hal played for the Chicago Cubs, Cincinnati Reds, and St. Louis Cardinals after spending two seasons with the Nashville Vols. In 1947, he led the Southern Association with 218 hits while batting .346 for the season. (Courtesy Mike Cunningham.)

THE MAYOR OF SULPHUR DELL. Nashvillian Harold "Buster" Boguskie played for eight seasons for the Vols beginning in 1947. On opening day, April 16, 1948, Boguskie went six for seven at the plate and was called out at first on a close play after a swinging bunt that kept him from recording a seventh hit. (Courtesy Gail Boguskie Wilson.)

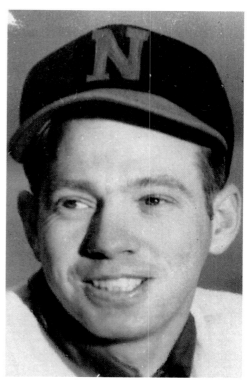

HAROLD "BUSTER" BOGUSKIE. In 1952, Boguskie anchored second base in an infield that set a record for double plays in a season with 202. His best year at the plate came in 1951, when he batted .322 for the season. He later became a local sporting goods salesman and city councilman. (Author collection.)

FANS IN THE OUTFIELD. When large crowds turned out at Sulphur Dell and filled the grandstand, fans took their seats on the outfield hills. Although the team's attendance declined in the 1950s, exhibition games between major-league teams heading north from spring training usually drew the best gates. (Courtesy Mike Cunningham.)

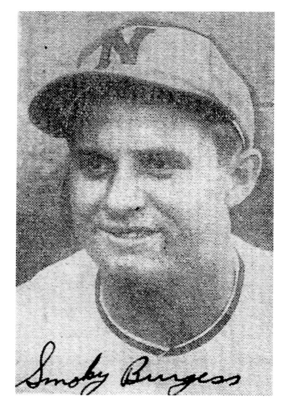

FOREST "SMOKY" BURGESS, 1948. Burgess led the Southern Association with a .386 batting average in 1948. As a catcher and outfielder he drove in 102 runs while slamming 22 home runs in the team's first-place finish. Burgess went on to a major-league career and became known as a successful pinch hitter. (Author collection.)

THE LARRY GILBERT YEARS

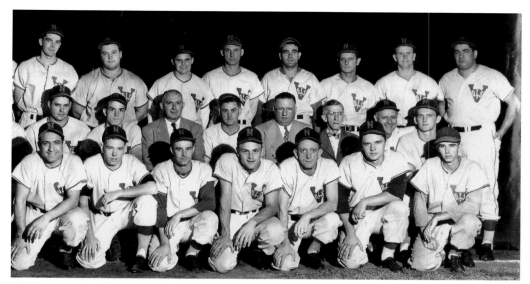

CHAMPIONSHIP TEAM, 1949. One season after Larry Gilbert retired as manager of the Vols to join the front office, manager Rollie Hemsley lead the team to the 1949 Southern Association championship with a power-hitting club. The locker room saw its share of celebrating. (Courtesy Nashville Public Library, the Nashville Room.)

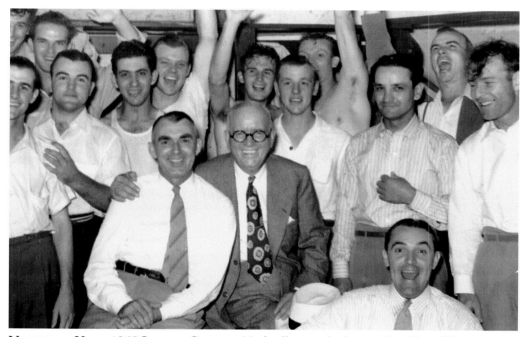

NASHVILLE VOLS, 1949 LEAGUE CHAMPS. Nashville won the league playoffs and Dixie League championship in 1949 as Bob Borkowski topped the league with a .376 batting average and Carl Sawatski hit 45 home runs and batted in 153 runs. Pitcher Pete Mallory led the pitching corps with 20 wins. (Author collection.)

HAROLD "TOOKIE" GILBERT. After joining Nashville in 1949, Tookie led the Southern Association with 149 runs. He played a portion of two seasons with Leo Durocher's New York Giants. After his playing career, he became a sheriff in Orleans Parish, Louisiana. He died of a heart attack at the age of 38 in 1967. (Courtesy Derby S. Gisclair/Helen Gilbert.)

CHARLIE GILBERT. Charlie Gilbert joined his father's team in Nashville in 1939. An outfielder, he batted .317 in his first season with the Vols. After stints in the major leagues, Charlie played again for Nashville in 1943 and 1948. He joined the Vols' front office when his playing career was over. (Courtesy Derby S. Gisclair/Helen Gilbert.)

THE LARRY GILBERT YEARS

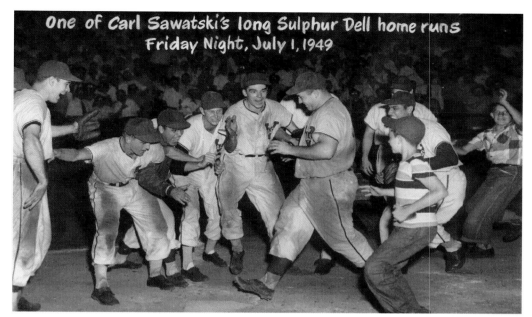

One of Carl Sawatski's long Sulphur Dell home runs Friday Night, July 1, 1949

GRAND-SLAMMER CARL SAWATSKI. Sawatski hit five grand slams during the 1949 season and added another in the Dixie Series against Tulsa. The home run he hit on opening day, April 15, 1949, has been considered the longest ever hit by a Vol player. Caught in the Chattanooga wind, it traveled a distance of at least 520 feet from home plate, authenticated by sportswriter Fred Russell. (Courtesy Nashville Public Library, the Nashville Room.)

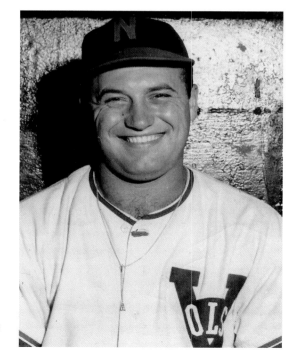

CARL "SWISH" SAWATSKI. Later to become president of the Southern League after playing in the big leagues and serving as general manager of the Arkansas Travelers, Sawatski led the Southern Association with 45 home runs and 153 RBIs in 1949. (Courtesy Nashville Public Library, the Nashville Room.)

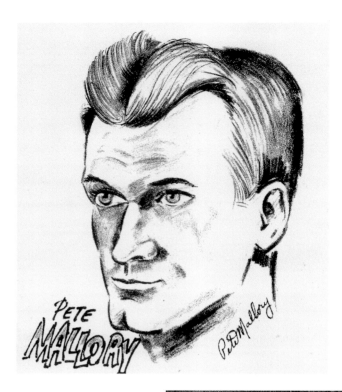

PETE MALLORY, 1949. In 1949, Pete Mallory was instrumental in leading the four-man rotation with a 20-4 pitching record. With an ERA of 3.89, Mallory struck out 110 opposing batters in Nashville's title run. (*Sabatini Sketchbook.*)

CHARLES "BAMA" RAY. Bama Ray joined the Vols in 1949 as an outfielder and was on the team for four seasons. During 1951, his batting average was a personal best of .338 with 18 home runs. He returned in 1952 to hit .303 and duplicated his previous year's home run total. (*Vol Feats, Nashville Banner.*)

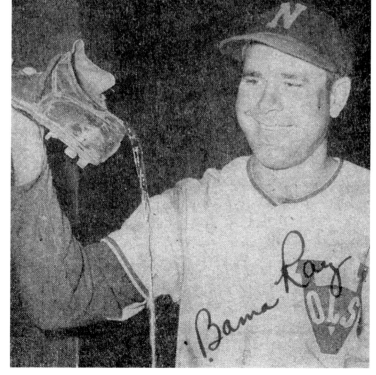

VOL FEATS BOOKLET. Published by the *Nashville Banner* in 1951 and cowritten by sportswriters Fred Russell and George Leonard, *Vol Feats 1901–1950* is a pocket-sized history of the Nashville Vols. It contains factual accounts of game and season highlights, player and manager profiles, and trivia about the team. (Author collection.)

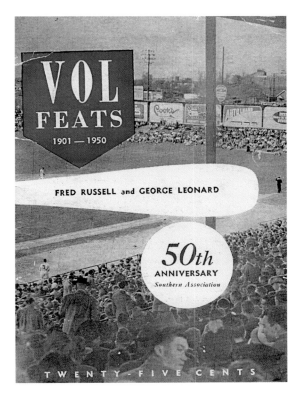

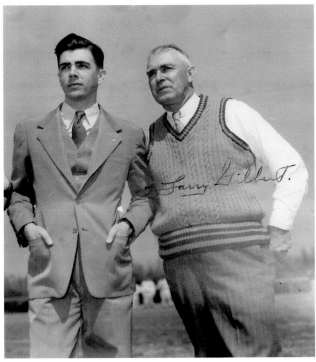

GEORGE LEONARD (LEFT) AND LARRY GILBERT (RIGHT). In covering the Vols for the *Nashville Banner*, Leonard would often accompany the team to spring training. Larry Gilbert, who had retired from managing but had kept his position as vice-president of the club, is shown with Leonard at spring training in Florida. (Courtesy Nashville Old Timers Baseball Association.)

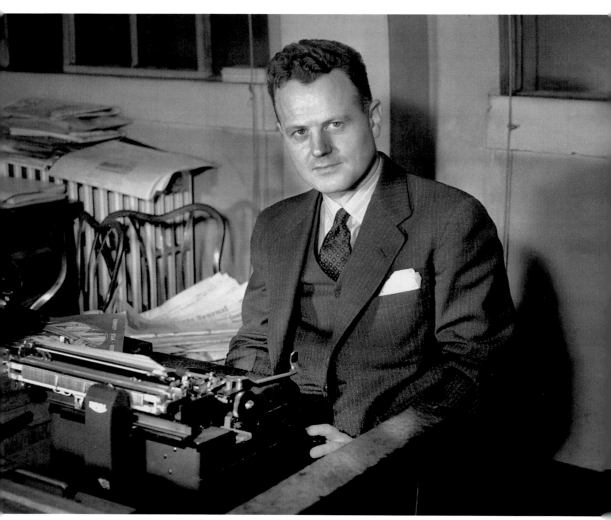

Sportswriter Fred Russell. Born August 27, 1906, in Nashville, Russell was a nationally known sportswriter. After graduation from Duncan Prep, he enrolled at Vanderbilt University and played on the 1925–1926 Commodore baseball teams. Hired in 1929 by the *Nashville Banner*, he remained there until the paper closed in 1998. (Courtesy Nashville Public Library, the Nashville Room.)

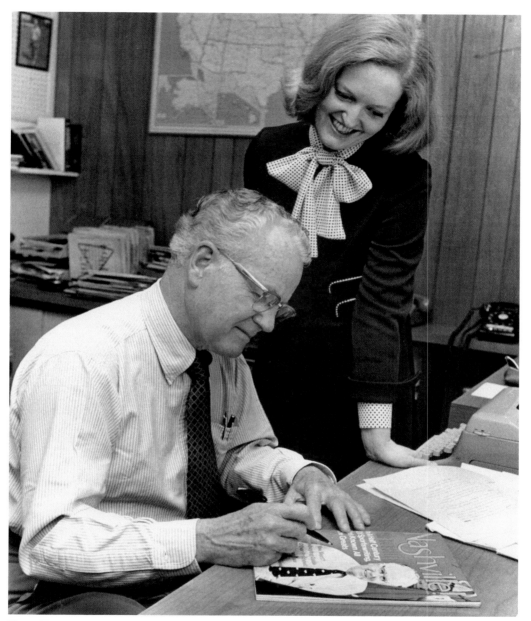

FRED RUSSELL. Russell was an avid baseball fan and took great delight in covering the Nashville Vols. Known for his "Sidelines" sports column in the *Banner*, he collaborated with George Leonard in 1951 to publish *Vol Feats*, a booklet about the first 50 years of the Nashville baseball team. (Courtesy Nashville Public Library, the Nashville Room.)

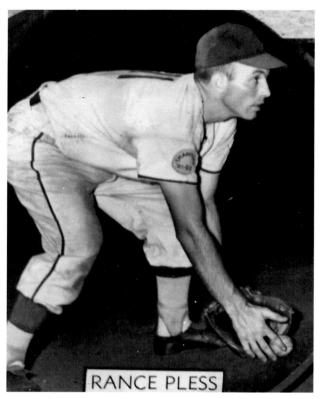

RANCE PLESS

RANCE PLESS. In 1952, third baseman Rance Pless led the Southern Association with 196 hits and a .364 batting average. He returned to the league in 1960, playing a total of 85 games with Birmingham and Little Rock after a brief appearance in the majors with the Kansas City Athletics in 1956. (Author collection.)

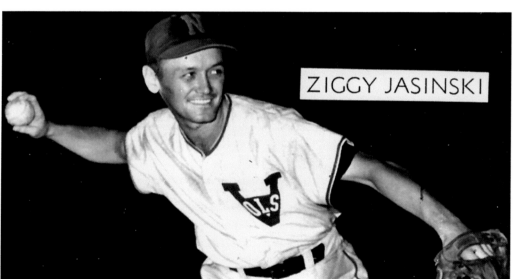

ZIGGY JASINSKI

"ZIGGY" JASINSKI. In his only season with the Nashville Vols, Jasinski played shortstop in 120 games and batted .259 for the season. He and second baseman Buster Boguskie were the infield cornerstones that set a Southern Association record of 202 double plays for a season in 1952. (Author collection.)

JIM MARSHALL. This future major-league manager was the first baseman during the 1952 Vols season. Batting .296 and slamming 24 home runs, he knocked in 98 runs and had 38 triples. Marshall went on to manage the Chicago Cubs and Oakland Athletics and later became a scout. (Author collection.)

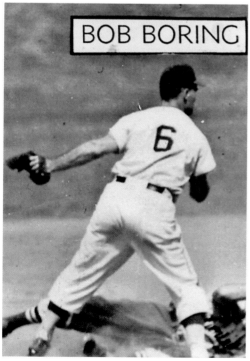

BOB BORING. In the first of two seasons with the Vols, this utility infielder hit for a .323 average in 1952 while playing 80 games at second base and 45 games at shortstop, filling in for Jasinski and Boguskie. He returned to the Vols in 1953 and led the league with 612 plate appearances. (Author collection.)

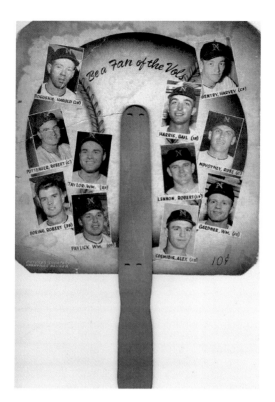

NASHVILLE VOLS FAN, 1953. The Nashville Vols were known for promoting team members, and the photographs printed on both sides of this fan highlighted the team's players. Popular players Harold "Buster" Boguskie, Pete Modica, and future major-leaguers Jack Harshman and Gail Harris were members of the 1953 team. (Author collection.)

COUNTRY MUSIC'S HANK WILLIAMS. An avid Brooklyn Dodger fan, Williams supported the Nashville Vols during his time in Music City. While traveling between show dates, he was known to have worked the radio dials to find a baseball game being broadcast, often even switching back and forth between stations listing to more than one game a time. (Courtesy Brian Turpen.)

JOE STUPAK. Joe Stupak spent one season with the Vols in 1954, compiling a 9-16 record. He started 27 games and appeared in 15 others as a reliever, striking out 83 batters in 196 innings. The team finished tied for sixth place, 30 games behind league-leading Atlanta. (Author collection.)

HUGH POLAND. Joining the Vols as manager in 1952, Hugh Poland had clubs that never won the pennant, but his rosters were loaded with hitters such as Bob Lennon and Dusty Rhodes. His managing record in Nashville was 222-238. Poland helped to chart the major-league success of pitcher Al Worthington and first baseman Gail Harris. In 1955, he became a scout for the New York Giants. (Author collection.)

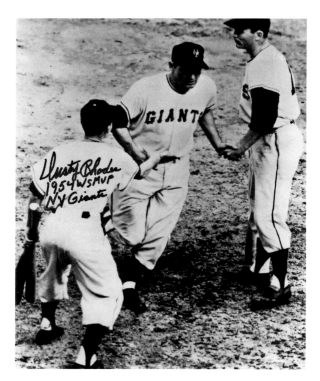

JAMES "DUSTY" RHODES. Called up from Nashville by the New York Giants, Rhodes nailed a pinch-hit home run in the bottom of the 10th inning off of Bob Lemon to win the first game of the 1954 World Series. The next day, he delivered a pinch-hit single in the fifth inning. He was named the World Series Most Valuable Player as the Giants won four games to none. (Author collection.)

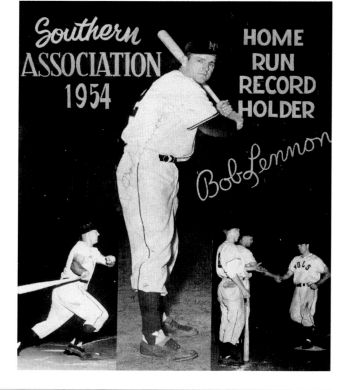

BOB LENNON. Power-hitter Bob Lennon hammered 64 home runs for the Nashville Vols in 1954, blasting 47 at Sulphur Dell. In a season-ending doubleheader, Lennon hit three homers to finish as the all-time Southern Association single-season leader, a record never equaled in the 61-year history of the league. (Author collection.)

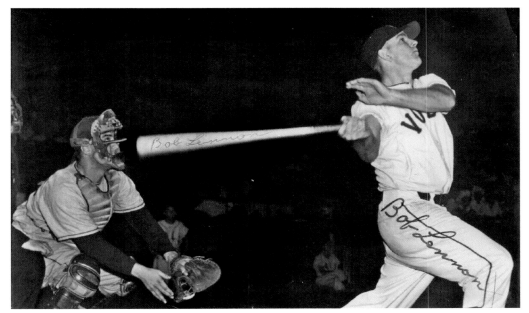

LEAGUE MVP BOB LENNON. Lennon was the league's Most Valuable Player in 1954 as he hit 64 home runs with 161 RBIs and a .345 batting average to win the league's Triple Crown. Lennon was called up at the end of the season by the New York Giants. (Author collection.)

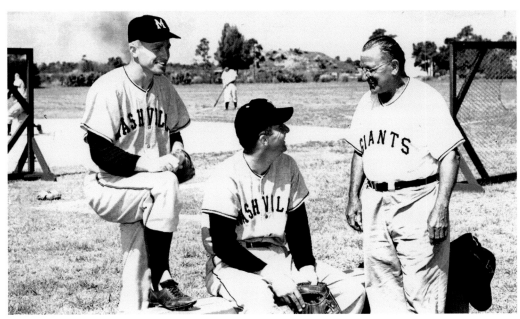

VOLS IN SPRING TRAINING. During spring training in 1954, pitchers Jim Graves (left) and Dick Libby (center) take a break to speak with the New York Giants trainer. Graves only appeared in five games with the Vols during the season, but Libby finished 12-16. Libby's ERA was 6.20 as he struck out 102 batters in 183 innings. (Author collection.)

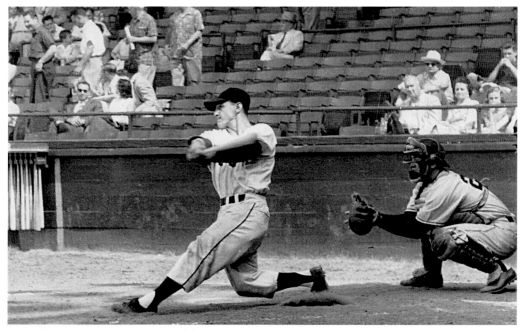

ALEX COSMIDIS, 1954. A second baseman and shortstop, Alex Cosmidis hit .276 in 1954 after a short season the summer before. Cosmidis spent some time after his playing career as a minor-league manager and in 1967 was selected as top manager while at Appleton in the Midwest League. (Author collection.)

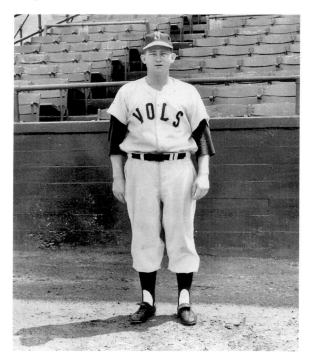

ROY PARDUE. Pardue was a graduate of North High School in Nashville. He joined the Vols for one game in 1952 and, after serving in the military, rejoined the team in 1955. He led that team as the ace of the staff with a 17-10 record followed by a 12-12 season in 1956. (Author collection.)

THE LARRY GILBERT YEARS

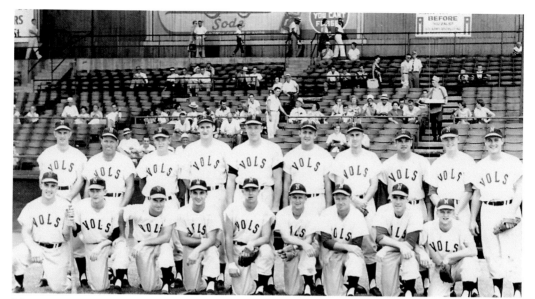

NASHVILLE VOLS, 1955. In 1955, the Nashville Vols began a working agreement with the Cincinnati Reds to become a minor-league farm club for the major-league team. It began an amiable relationship with the Reds and their general manager, Gabe Paul, a highly respected baseball executive. (Author collection.)

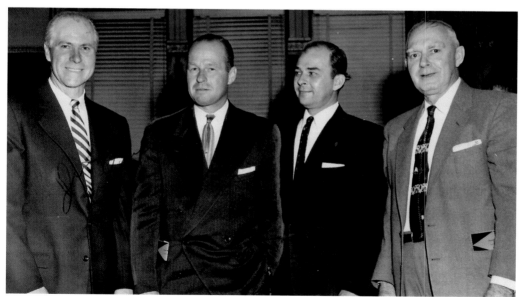

JOE SCHULTZ. Future major-league manager Joe Schultz led the Nashville squad in 1955. His club finished in fifth place with a 77-74 record, 12 games behind Memphis. In 1969, he would become the first and only manager of the Seattle Pilots, an expansion franchise that would move to Milwaukee the next season. From left to right are Jim Turner, Joe Schultz, Charlie Gilbert, and Larry Gilbert. (Author collection.)

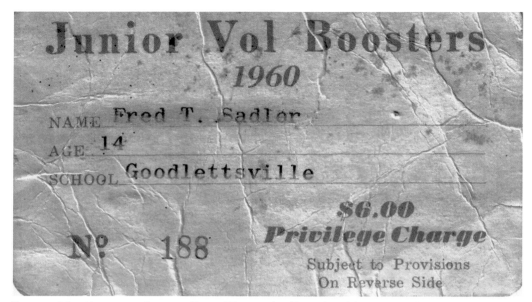

JUNIOR VOL BOOSTER SEASON PASS. The Nashville Vols sold passes at discounted prices to youngsters for $6 that would gain them entry into any game during the season. Combined with promotions such as "Knothole Gang" nights, the team attempted to bring baseball to young fans. (Courtesy Fred Sadler.)

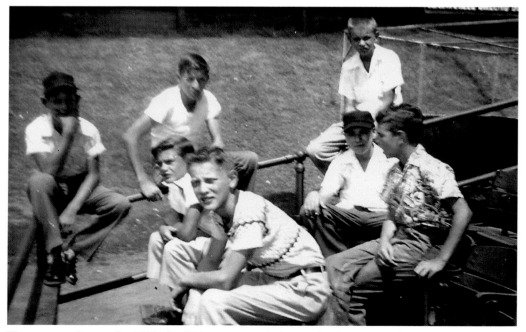

KNOTHOLE GANG. In 1956, the Vols recognized the Nashville Junior Chamber of Commerce sponsorship of Knothole Baseball, which allowed boys across the city to participate on one of 56 teams divided into eight leagues by designating a game as "Knothole Night." (Author collection.)

THE LARRY GILBERT YEARS

HARRY "WAR HORSE" ROGERS.
The Nashville Old Timers Baseball
Association was formed in 1939 by
a group of baseball enthusiasts and
led by its first president, Harry "War
Horse" Rogers. The Old Timers
creed reads, "To enjoy fellowship
with baseball enthusiasts and to
honor and support the great game
of baseball." (Courtesy Nashville
Old Timers Baseball Association.)

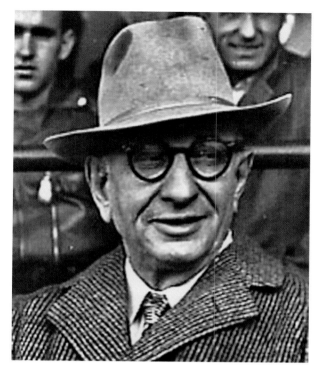

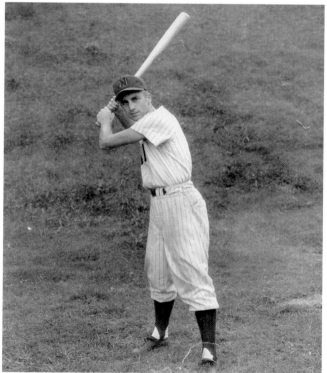

LARRY TAYLOR. Taylor's first
season with Nashville was
in 1955, playing three infield
positions in 110 games. In
1956, he played second base
the entire season, batting for
a .281 average. He remained
with the Vols until 1958, when
a manager's position became
open with Visalia, California.
Taylor later became the
head baseball coach at Berry
College in Rome, Georgia.
(Larry Hand photograph.)

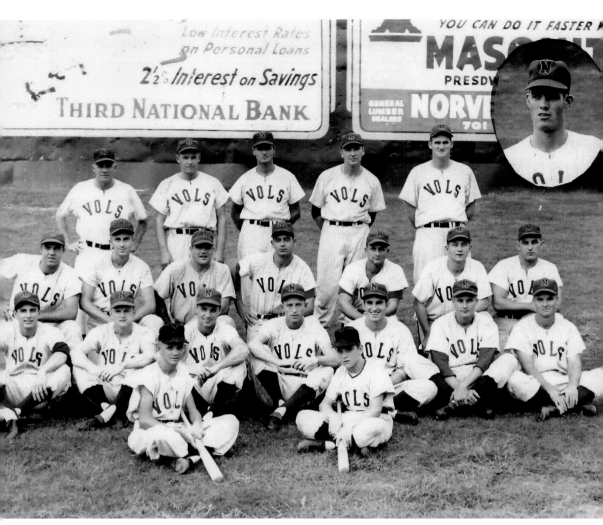

NASHVILLE VOLS, 1956. Manager Ernie White led the 1956 team to a seventh-place finish in the Southern Association with a 75-79 record. Team members are, from left to right, (first row) batboys Bobby Woodall and Mike Adams; (second row) Rick Botelho, Bobby Durnbaugh, Bill Werber, Ralph "Country" Brown, Jerry Davis, John Brechin, and Bob Kelly; (third row) George Schmees, Larry Taylor, Frank Baldwin, Tommy "Buckshot" Brown, Charlie Williams, Roy Pardue, and Matt Batts; (fourth row) manager Ernie White, Mike Lutz, Stan Hollmig, Frank Smith, and Cal Howe. The player in the inset is Charlie Rabe. "Country" Brown led the team with a .316 batting average, and George Schmees led with 22 home runs. Pitcher Robert Kelly led the league with 180 strikeouts but also had the most losses with 16. Cal Howe led in games pitched with 58. (Larry Hand photograph.)

THE LARRY GILBERT YEARS

BOBBY DURNBAUGH. A shortstop by trade, Bobby "Scroggy" Durnbaugh's first season in Nashville was 1955. His last year with the Vols was in 1959, and he also spent a few games on the roster of the Cincinnati Reds in 1957. Scroggy was elected Vols Player of the Year in 1956. (Author collection.)

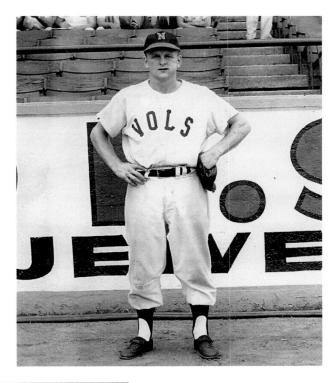

EARL AVERILL. A Nashville catcher and son of Hall of Famer H. Earl Averill, he hit three consecutive home runs and two doubles to set a new league mark for total bases with 16 on August 20, 1955. (Author collection.)

THOMAS "COUNTRY" BROWN.
A journeyman minor leaguer,
Brown was a third baseman
for the Vols from 1955 through
1957, batting .316 in 1956. He
also played for Chattanooga and
New Orleans in the Southern
Association. (Author collection.)

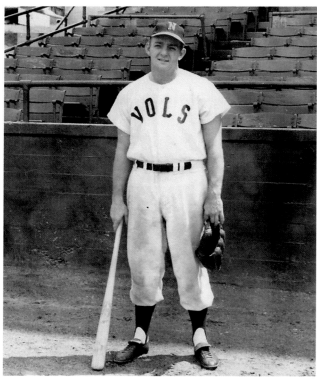

BEN DOWNS. Ben Downs hit for
a .340 average as an outfielder
with Nashville in 1955 and later
spent time with Little Rock and
Memphis. (Author collection.)

CALVIN HOWE. A relief pitcher, Howe led the Southern Association in games pitched in 1956 with 58. He was with Nashville from 1955 through the 1957 season. (Author collection.)

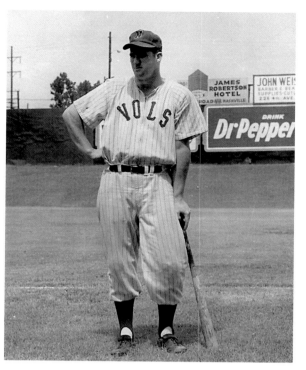

TOMMY "BUCKSHOT" BROWN. Brown began his major-league career with the Brooklyn Dodgers when he was 16 years old. He became the youngest player to hit a home run in the majors on August 20, 1945, with a shot at Ebbetts Field at the age of 17. In 1955, Brown joined the Vols and in 1956 batted for a .316 average. (Author collection.)

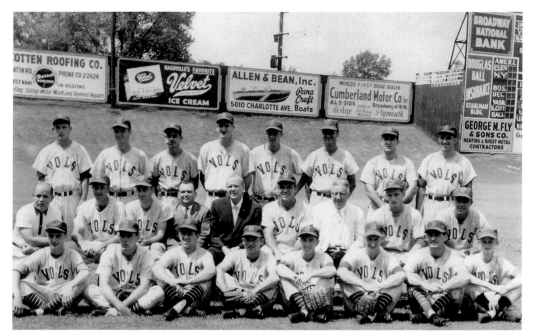

NASHVILLE VOLS, 1957. Former major-leaguer Dick Sisler assumed command of the team in 1957, and the Vols finished in third place in the Southern Association. Sisler was a player/manager and batted .332 while playing first base. Robert Kelly won 24 games to lead the league after leading the league in losses the previous season. (Author collection.)

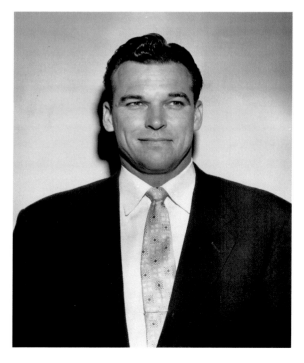

DICK SISLER. Son of Hall of Famer George Sisler, Sisler spent his major-league career with the St. Louis Cardinals, Philadelphia Phillies, and Cincinnati Reds. On the last day of the 1950 season at Ebbets Field, he hit a home run for the Phillies that gave the "Whiz Kids" their first National League pennant. After managing the Nashville Vols and Seattle Rainiers in the minor leagues, Sisler became a coach for Cincinnati in 1961. In August 1964, Sisler was promoted to acting manager under tragic circumstances when Fred Hutchinson, suffering from cancer, had to give up the reins. After leaving the majors, Sisler returned to Nashville as a hitting instructor for the Sounds in 1982. Dick Sisler died in Nashville at age 78. (Author collection.)

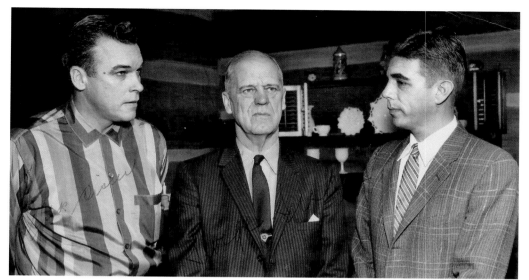

FAMILY AFFAIR. Dick Sisler (left) and his father, Hall of Fame member George Sisler (center), join George Leonard at a dinner in Dick Sisler's Nashville home. The elder Sisler was one of the all-time greats and was inducted into Cooperstown in 1939. He played for the St. Louis Browns, Washington Senators, and Boston Braves. (Courtesy Nashville Public Library, the Nashville Room.)

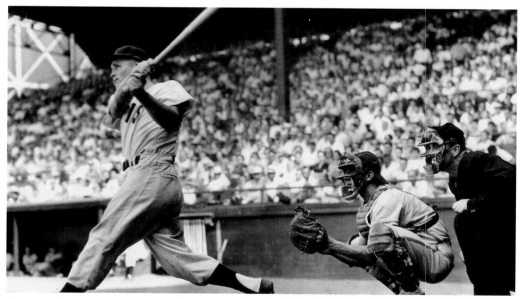

CHARLIE WILLIAMS. Williams takes a cut in front of a packed house at Sulphur Dell. Attendance began to wane in the mid-1950s, and trouble was in the future for the fabled franchise. Air-conditioned homes, the rise of popular television programming, and failure of Vols management to promote their game were among the causes for attendance to decline as Sulphur Dell began to suffer disrepair. (Author collection.)

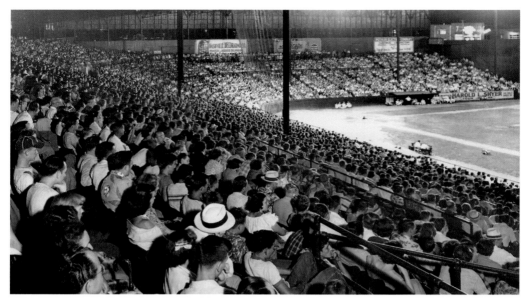

GRANDSTAND VIEW. Ted Murray and Larry Gilbert, co-owners of Nashville in the Southern Association, announced in 1955 that they might lose their franchise. Attendance at Sulphur Dell had been strong throughout the 1930s and 1940s, but declining attendance forced Murray and Gilbert to face the reality of losing the club. It was reported that Knoxville, Jacksonville, and Tampa were anxious to obtain the franchise. (Courtesy *Nashville Banner.*)

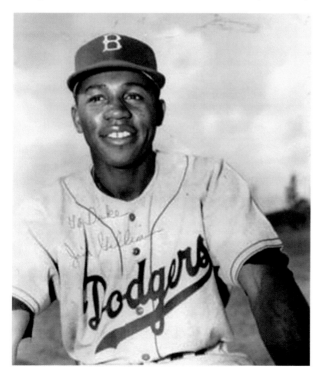

JIM "JUNIOR" GILLIAM. Born in Nashville, Gilliam signed with the Brooklyn Dodgers in 1951. He took over second base from Jackie Robinson, who shifted to third base and the outfield. Gilliam retired as a player following the 1966 season with a .265 career batting average with 1,889 hits, 1,163 runs, 558 RBIs, 304 doubles, 71 triples, and 203 stolen bases over 14 seasons. (Private collection.)

THE LARRY GILBERT YEARS

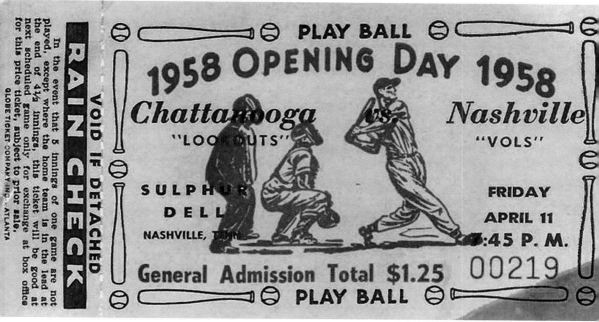

OPENING DAY TICKET, 1958. Attendance continued to dwindle, and 1958 was the last year for the Murray family to own the Nashville baseball club. At the end of the season, local businessmen and civic leaders formed Vols, Inc., to purchase the team and keep professional baseball alive in Nashville. (Author collection.)

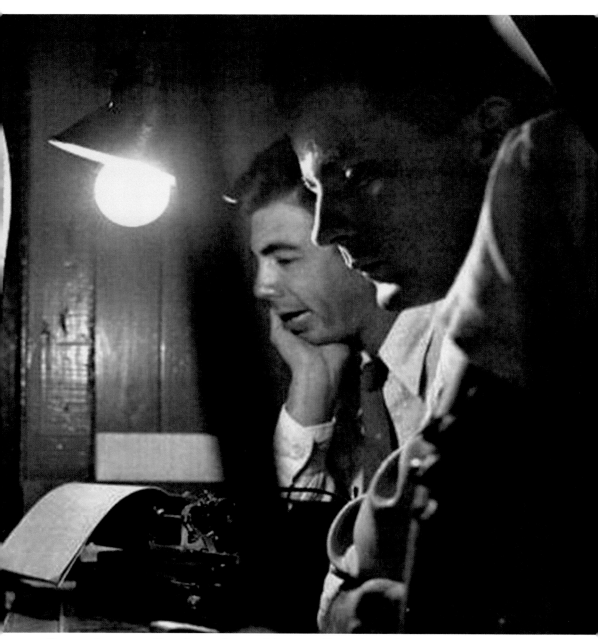

George Leonard (Left) and Larry Munson (Right). In the press box at Sulphur Dell, popular announcer Larry Munson shares the booth with sportswriter George Leonard. When the Milwaukee Braves moved to Atlanta, Munson became an announcer for the team. He later became announcer for the Atlanta Falcons and the University of Georgia. (Courtesy Steve Cavanagh.)

DESPERATE TIMES

*I remember the spirit of Sulphur Dell, even in its dying days. The crowds were sparse,
the old stadium needed a good facelift, but the magic of the game and the exciting feeling
of another game, another pitch, and the crack of the bat never lost its allure.
For a few fans, a sportswriter named George Leonard (my Dad), and an 8-year-old kid,
every game was exciting. I learned about scoring a game, how to run a scoreboard, and how
to catch a foul ball at the Dell. For me, the stadium has many fond memories. I have a great
photo of my Dad in the press box, hammering out another story on an old "Royal" typewriter,
as he views the field below. My Dad was in his element at the Park, and so was I!*

—Ernie Leonard, Nashville

From the 1955 through the 1959 seasons, average attendance in Nashville was 266 fans per game.
The Southern Association refused to integrate its rosters, and fans did not support the team at the
gate. Over the years, the Vols had been affiliated with the New York Giants, Brooklyn Dodgers,
and Chicago Cubs, but as a farm club of the Cincinnati Reds, the quality talent that the Reds
provided did not bring more fans to the games.

Larry Gilbert sold his share of the Nashville Vols in 1955 to his co-owner, T. L. Murray. In a
few years, Murray became financially strapped and sold his team to an ownership group that was
formed by local businessmen. Herschel Greer, Eddy Arnold, Jack Norman, J. R. Coarsey, John
Ragsdale, Dr. Cleo Miller, Jimmy Miller, John U. Wilson, Vernon Williams, Joe Sadler, Joe Carr,
Al Greer, Bill Lambie Jr., and Al Lynx formed Vols, Inc., in January 1959 to keep the club alive.
Shares in the new venture were sold at $5 each, and 4,876 investors became stockholders.

Dick Sisler left as manager to join the Seattle Rainiers and New York Yankees as pitching coach, and
Nashville native Jim Turner was hired as field general in 1960. The team finished in sixth place with a
71-82 record with John Edwards, Rod Kanehl, and Jim Maloney on the team, but declining attendance
set the tone for the team and the league. Turner left after his one-year tenure and returned to the
majors as a pitching coach for the Cincinnati Reds and later returned to the New York Yankees.

The failure by the Southern Association board of directors to integrate its rosters held some
responsibility for sliding attendance. Civil rights laws and interpretations were changing, and
the league failed to do what many other minor leagues across the country had done: sign black
players. Future Hall of Fame member Frank Robinson was on the spring training roster of the
Vols in 1955 and 1956, but he was never allowed to head north to begin the season with the
Southern Association team.

Continued declining attendance doomed the club, and the death knell of the Southern
Association in 1961 ended the Nashville Vols' participation in the old league. As a farm club of
the Minnesota Twins that year, interest waned not only in the team but the rickety old ballpark
as well. In 1962, there was no professional baseball in Nashville.

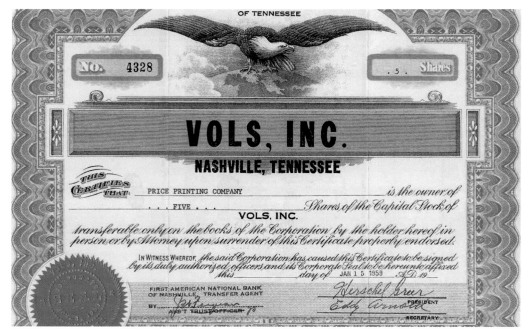

VOLS, INC., STOCK CERTIFICATE. Local businessmen rallied loyal supporters to commit to purchase $5 shares to form Vols, Inc., and save the Nashville franchise from folding. A total of 4,876 investors purchased shares and became stockholders in the team. Included on the board of directors were country music star Eddy Arnold, John A. McPherson, and Herschel Greer. (Author collection.)

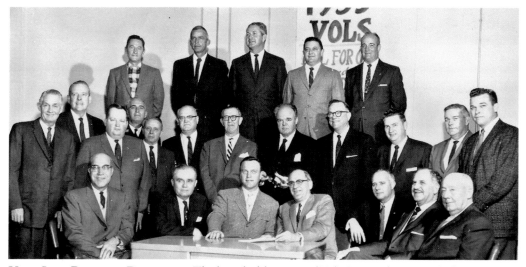

VOLS, INC., BOARD OF DIRECTORS. The board of directors of Vols, Inc., gathers in 1959 for a meeting. Dick Sisler, Bill McCarthy, Al Linx, John U. Wilson, Vernon Williams, Dr. Cleo Miller, Jimmy Miller, Nashville fire chief John Ragsdale, Bill Lambie Jr., J. R. Coarsey, Al Greer, Jack Norman, Joe Carr, Eddy Arnold, Joe Sadler, and Herschel Greer were members of the board. (Courtesy Nashville Public Library, the Nashville Room.)

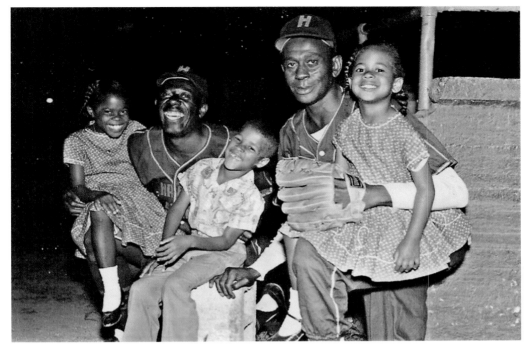

GOOSE TATUM (LEFT) AND SATCHEL PAIGE (RIGHT). In an exhibition game in 1962 at Sulphur Dell, Tatum and Paige are shown with local children. Paige, who was inducted into the National Baseball Hall of Fame in 1971, had a distinguished Negro League career as well as becoming a feared pitcher in the major leagues. (Courtesy Metropolitan Government Archives of Nashville and Davidson County.)

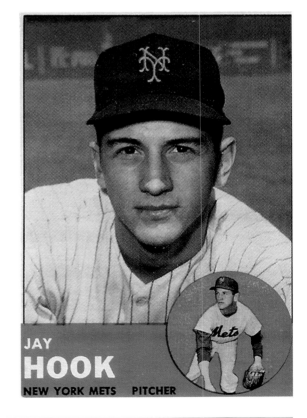

JAY
HOOK
NEW YORK METS PITCHER

JAY HOOK. Playing for the Nashville Vols in 1958, Hook went on to a career as a pitcher for the Cincinnati Reds and New York Mets. Taken in the 1961 Expansion Draft by the Mets, he won the first game in Mets franchise history on April 23, 1962, tossing a five-hit 9-1 victory over the Pittsburgh Pirates at Forbes Field. (Private collection.)

BASEBALL IN NASHVILLE

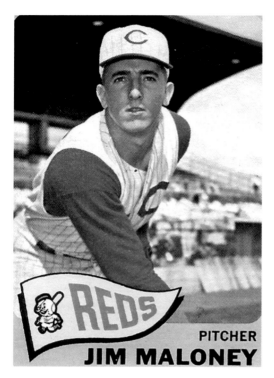

PITCHER
JIM MALONEY

JIM MALONEY. A right-handed pitcher with the Cincinnati Reds and California Angels, Maloney boasted a fastball clocked at 99 miles per hour and threw three no-hitters, striking out more than 200 batters for four consecutive seasons (1963–1966). His minor-league career included a season with the Nashville Vols in 1960 and a 14-5 record. (Private collection.)

O'TOOLE AND VANDER MEER. Jim O'Toole spent the 1958 season with the Vols, leading the league with 20 wins, 21 complete games, 280 innings pitched, and 189 strikeouts. Assisting O'Toole with his form is Johnny Vander Meer, who pitched consecutive no-hitters in the majors. Vander Meer pitched in 10 games with the Vols in 1936. (Associated Press Wirephoto.)

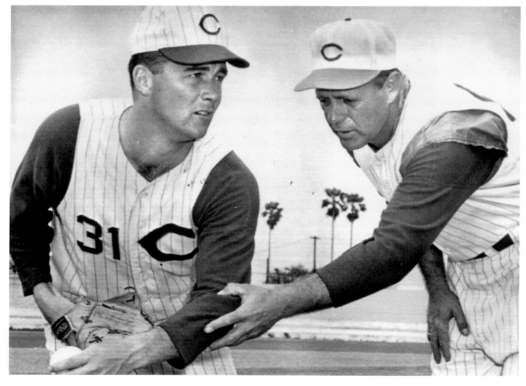

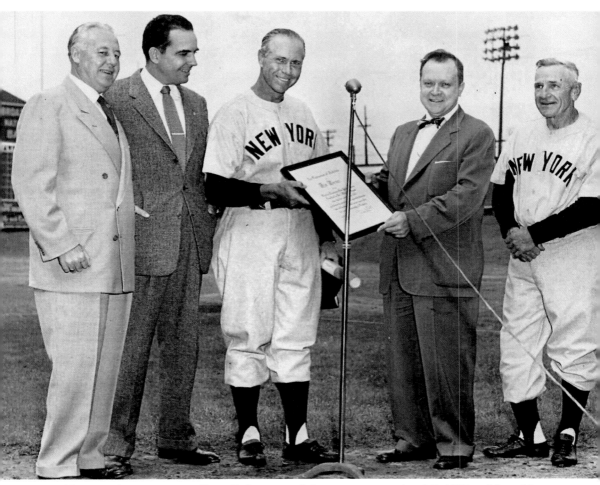

JIM TURNER APPRECIATION DAY. Before an exhibition game on April 7, 1953, public address announcer Herman Grizzard, Gov. Frank Clement, Mayor Ben West, and Yankees manager Casey Stengel stand with Jim Turner at home plate. The popular pitching coach for the Yankees was honored with a declaration by the mayor on Jim Turner Appreciation Day. (Courtesy Metropolitan Government Archives of Nashville and Davidson County.)

JOSEPH "BLACK CAT" REILLY. Born in 1922, "Black Cat" was a passionate fan at Nashville's amateur and professional ballgames and was known for putting his "Black Cat Hex" on opposing teams. He spent most of his life selling newspapers downtown and was a favorite of New York Yankees owner George Steinbrenner. (S. A. Tarkington photograph.)

ROD KANEHL. Kanehl hit the first grand slam in New York Mets history on July 6, 1962, at the Polo Grounds. A favorite utility man of Casey Stengel, Kanehl was the only former Mets player who was present at Stengel's funeral when he died in 1975. Playing for the Nashville Vols in 1960 and 1961, Kanehl batted .304 during his last season with the team. (Private collection.)

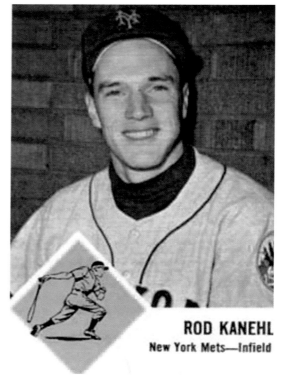

ROD KANEHL
New York Mets—Infield

GEORGE ARCHIE. This Nashvillian was 24 years old when he began playing for the Detroit Tigers. He also spent time with the Washington Senators and St. Louis Browns. He was assistant coach during Jim Turner's year with the Nashville Vols in 1960 and again in 1963. He spent two seasons as baseball coach at Vanderbilt University in 1965 and 1966. (Courtesy Nashville Old Timers Baseball Association.)

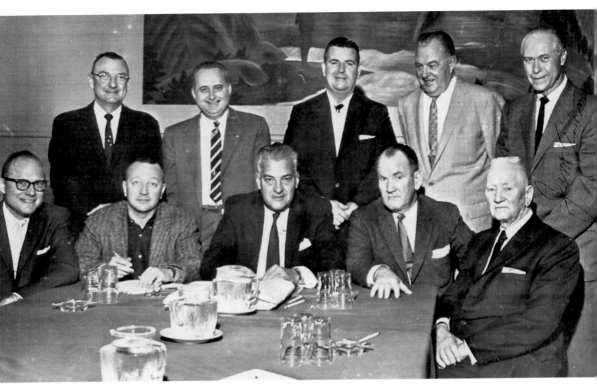

Southern Association General Managers. Jim Turner (standing, far right) was Nashville's representative at the 1960 Southern Association general managers' meeting; Joe Engel of the Chattanooga Lookouts stands next to Turner. Seated in the middle is Charlie Hurth, president of the league, and to his immediate left is Eddie Glennon of the Birmingham Barons. (Associated Press Wirephoto.)

DESPERATE TIMES

JIM TURNER AT SPRING TRAINING. In Tampa for spring training, Vols player Chuck Coles (left) takes instruction from Nashville manager Jim Turner (center) and coach Jack Cassini (right). Coles, a first baseman and outfielder, batted .290 for the 1960 season and hit 14 home runs. (Author collection.)

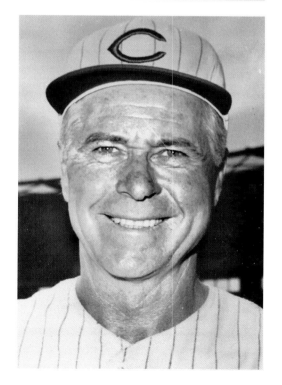

JIM TURNER. Turner pitched for the Boston Braves in 1937, his first year in the majors, winning 20 games and leading the National League with a 2.38 ERA. He became a successful pitching coach with the New York Yankees once his playing career ended. Turner returned to the major leagues as pitching coach of the Cincinnati Reds after managing the Nashville Vols for one season in 1960. (Author collection.)

BILL McCARTHY. McCarthy had a successful run as general manager of the Nashville franchise during the 1950s and worked closely with Vols, Inc.'s board of directors and manager Dick Sisler to keep the team profitable. Highly likeable among the press, McCarthy's attempt to bring fans to the games failed. (Author collection.)

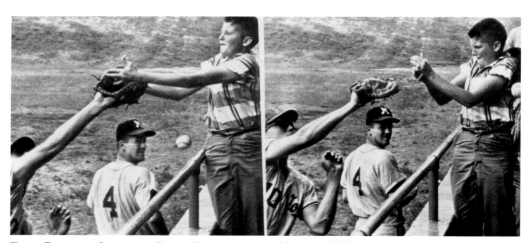

FOUL BALL AT SULPHUR DELL. Fourteen-year-old Larry Williams attempts to make a catch on a foul ball during a game in 1960 at Sulphur Dell. The unhappy first baseman who makes a play on the ball is Vol Frank Leja. The grinning bullpen catcher is Glenn Rosenhaus of Mobile. (Associated Press Wirephoto.)

DESPERATE TIMES

DEATH KNELL

FOR BASEBALL

The Vol board will consider offers for the park until Dec. 10, 1964. If none has been received by then
it was recommended that the land be disposed of "to the highest and best bidder and that the land
be held until an acceptable offer is received." By "acceptable," the committee said it meant "enough
to pay the stockholders and all debts." Three weeks ago the board surrendered Nashville's franchise
in the South Atlantic League following the club's poorest attendance in history. That action was
approved by the stockholders. Of the 50,000 shares of stock, 36,694 were represented at the meeting.

—George Leonard, *Nashville Banner*, October 8, 1963

With no baseball in 1962, the ownership group resurrected the Nashville Vols as a Los Angeles Angels farm club with membership in the South Atlantic League, a Class A league. Manager John Fitzpatrick welcomed players Henry Mitchell, Eddie Crawford, Jim Orton, Mike Sinnerud, Marvin Staehle, Dean Robbins, Dennis Waite, Don Ross, and Ron Hogg as the core of the team. George Archie, longtime manager for various local baseball teams and a former major leaguer, was brought in as a coach.

The board of directors of Vols, Inc., had voted in 1961 to end the ban on Negro players in Sulphur Dell as major-league teams would no longer allow for segregated rosters. Henry Mitchell and Eddie Crawford were in the Angels farm system and became the first of their race to join the Vols.

There was mounting criticism surrounding the controversial right field from league and team officials due to the potential for injury, and management considered leveling the entire surface. Costs to do so were prohibitive and the hills remained.

The public did not show their support, as less than 55,000 fans attended games during the 1963 season. It turned out to be the costliest season in Nashville Vols history; in September, faced with a debt of $22,000 and with no cash on hand, Vols, Inc., surrendered their South Atlantic League franchise.

The final day of baseball at Sulphur Dell was a double-header against Lynchburg on September 7, 1963, thus ending the storied history of Sulphur Dell.

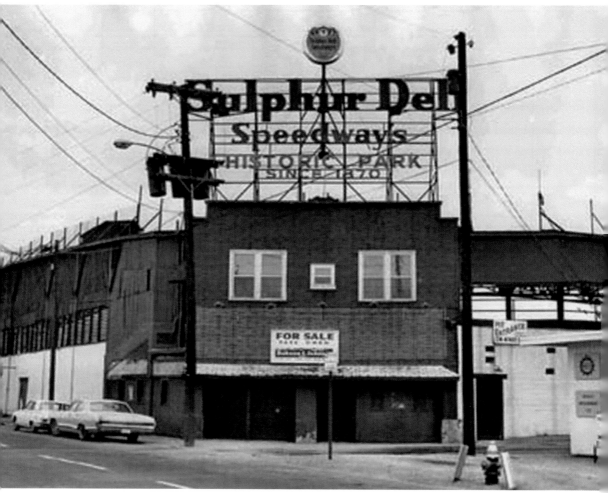

Sulphur Dell Speedways. After the Vols played their last game at Sulphur Dell in 1963, the park was silent until 1965, when country music singer Faron Young and local investor Pete Page purchased the old ballpark and converted it into Sulphur Dell Speedways. Small crowds forced the owners to close after 11 weeks of racing events. After becoming a city tow-in lot, the park was dismantled in 1969. (Dale Ernsberger photograph.)

SULPHUR DELL NO MORE, 1974. After the grandstand seats had been sold and the remaining components of Sulphur Dell had been demolished, the sunken field was filled in with rock and dirt. The area subsequently became a parking lot and tree-lined walkway, leaving a historical marker and memories as the only evidence of the ballpark's existence. (S. A. Tarkington photograph.)

SULPHUR DELL CENTERFIELD VIEW, 1974. Looking from where Nashville Vols centerfielders once stood and chased down fly balls near the flagpole, the state capitol and an office tower overlook James Robertson Parkway and the old ballpark area. Debris, dirt, rock, and concrete were used to fill the low basin. (S. A. Tarkington photograph.)

GAS TANK AND ICE HOUSE. All that remains of Sulphur Dell and its surroundings in 1974 is filled in, although what was once a Cook's Gas tank and the Atlantic Ice House building that sat just beyond the right field fence are still visible. These structures have since been demolished. (S. A. Tarkington photograph.)

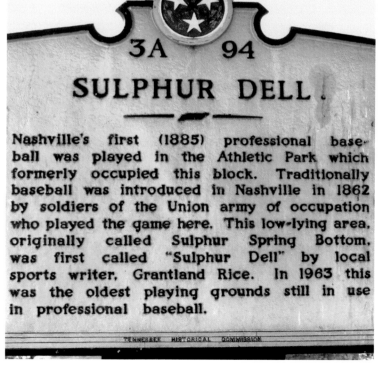

SULPHUR DELL HISTORICAL MARKER. When the ballpark was torn down in 1969, the area was developed into a parking area. The marker is on Fourth Avenue near where the centerfield fence once stood. The Farmers Market and Bicentennial Mall are a few short blocks west of the Sulphur Dell location. (Author collection.)

Baseball

Music City Style

I used to spend a lot of time watching the old Vols play down at Sulphur Dell. I've been waiting ever since that last Vols game for the day that this kind of entertainment came back to Nashville, and I'm glad the wait is over. I used to play on a church league softball team and we had our games down here at Ft. Negley. I even remember when they built the Ft. Negley park. I've been out here every night since they started building this park to watch how it went along.

—Sounds Fan William Lazenby in 1978

In 1978, Vanderbilt University baseball coach Larry Schmittou led a group of Nashville investors to found the Nashville Sounds of the AA Southern League after there was no professional baseball in the city from 1964 to 1977. Original owners of the Sounds included country music stars Conway Twitty and Jerry Reed. Herschel Greer Stadium was built near Fort Negley Park south of downtown Nashville, and the city led attendance totals for the Southern League in each of their seven seasons in the league.

The Sounds finished in ninth place in their inaugural year in 1978 but became one of the most successful minor-league franchises as attendance fueled the franchise's success. A Cincinnati Reds affiliate, the club drew 380,000 fans and led all of minor-league baseball in attendance. The team won Southern League titles in 1979 as an AA affiliate of the Cincinnati Reds and in 1982 as the AA affiliate of the New York Yankees.

After moving to Class AAA in 1985 and becoming a member of the American Association, an all-time attendance mark was set when 605,122 fans attended games at Greer Stadium in 1990. In 1993, the famous guitar-shaped scoreboard was added.

Also added in 1993 was a second team. When the Southern League had no place for one of its clubs to play, Larry Schmittou offered to host the team for the 1993 season. A Twins affiliate named the Xpress began its season, and games were scheduled around Sounds road games. The Xpress returned for another season in 1994 before relocating to Wilmington, North Carolina, for 1995. Birmingham outfielder Michael Jordan made several appearances in Nashville in Southern League action.

In 1985, two former Sounds players won their respective leagues' Most Valuable Player award. Willie McGee won in the National League as a member of the St. Louis Cardinals, and Don Mattingly won in the American League while playing for the New York Yankees.

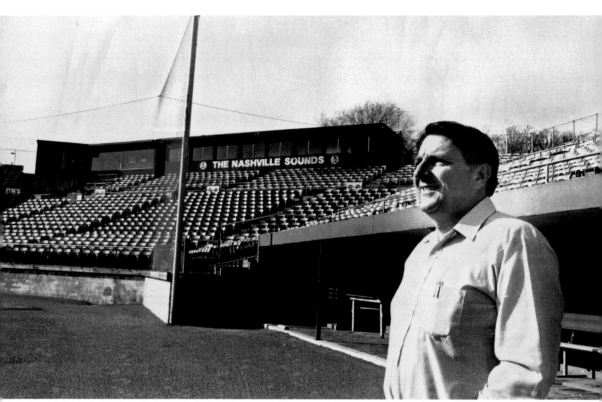

LARRY SCHMITTOU. After a 15-year hiatus, Nashville returned to baseball in 1978 as the Nashville Sounds, a Southern League expansion franchise team. Owner and general manager Larry Schmittou had been involved in the Nashville baseball scene for several years as manager of elite amateur teams and served as head coach of the Vanderbilt baseball team for 11 seasons, where he compiled a 306-252 record. He was instrumental in the reemergence of professional baseball in Nashville, where his penchant for bringing fans into the stadium included a star-studded ownership group and fan promotions that would become the norm for minor- and major-league teams across the nation. He also took on ownership in minor-league teams in Huntsville and Greensboro and for a time was an executive with the Texas Rangers. (Courtesy Nashville Public Library, the Nashville Room.)

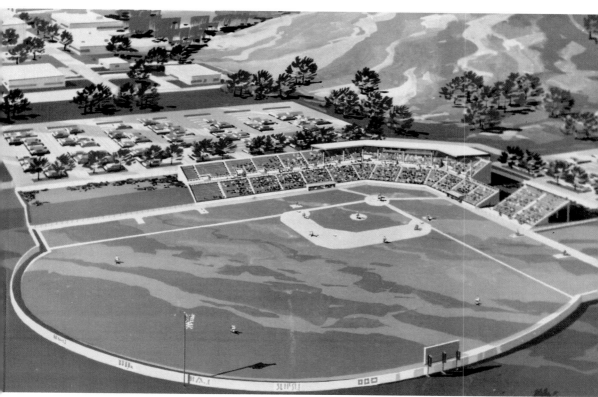

HERSCHEL GREER STADIUM. This early drawing of Herschel Greer Stadium shows the original design of the ballpark. Greer Stadium was built in 1978 as the home park of Nashville Sounds and named for local businessman Herschel Lynn Greer Sr., whose family donated $25,000 to begin stadium construction. Built at the foot of St. Cloud Hill near Fort Negley, a Civil War battle encampment site, the stadium has a seating capacity of 10,700. In the early years of the ball club, it was not unusual for a section of the outfield to be roped off to allow overflow crowds to enjoy a game. The Sounds plan to leave Greer Stadium after the completion of the 2007 season as a new stadium is to be constructed downtown. In 1992 and 1993, the Nashville Xpress, an AA team in the Southern League, played its home games there when the Sounds were on the road. (Courtesy Farrell Owens.)

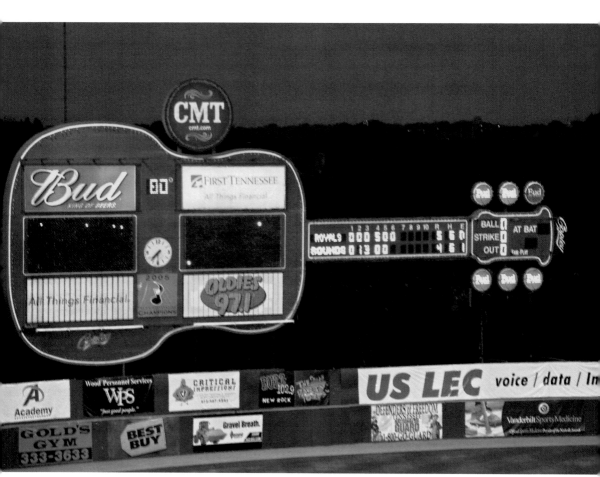

Guitar Scoreboard. In 1993, the Nashville Sounds owners constructed a giant scoreboard in the shape of a guitar painted in the team's colors, red and blue. The scoreboard was designed as a testament to the city's music heritage and is a popular feature of Greer Stadium. (Courtesy Nashville Sounds.)

ENTRANCE TO GREER STADIUM. Nashville's Herschel Greer Stadium was built at the foot of St. Cloud Hill near Fort Negley, constructed during the Civil War. Greer was home to both the AA Nashville Xpress in the Southern League and the AAA Nashville Sounds in the American Association for two seasons in 1993 and 1994. (Courtesy Nashville Sounds.)

GREER STADIUM THIRD-BASE SEATS. Fans have flocked to Greer to watch future major-league players Steve "Bye-Bye" Balboni, Wille McGee, Otis Nixon, Joe Price, Buck Showalter, and Don Mattingly play for the Sounds. The Sounds won Southern League pennants in 1979 and 1982 and the Pacific Coast League championship in 2005. (Courtesy Nashville Sounds.)

SOUTHERN LEAGUE CHAMPIONS, 1979. The Sounds faced the Eastern Division champions Columbus Astros in the best-of-five Southern League championship series, winning their first championship three games to one. (Courtesy Nashville Sounds.)

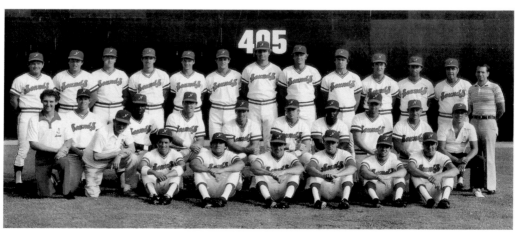

SOUTHERN LEAGUE CHAMPIONS, 1982. The Sounds defeated Memphis three games to one to advance to the championship series against Jacksonville, winning their second championship three games to one. (Courtesy Nashville Sounds.)

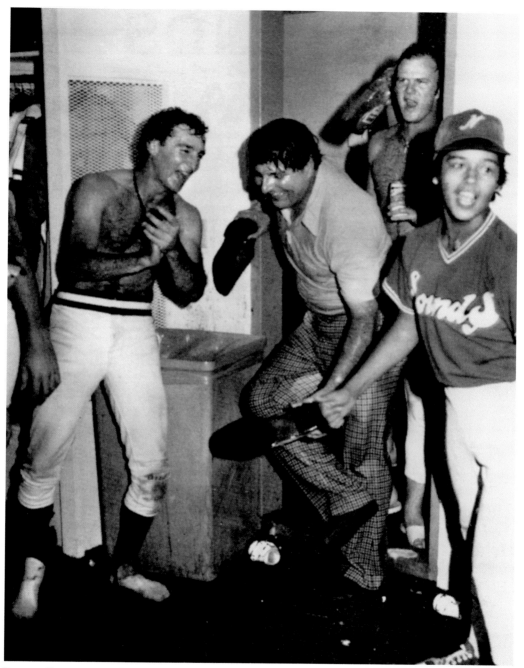

LARRY SCHMITTOU, LOCKER ROOM FESTIVITY. The Nashville Sounds celebrate their playoff victory as 1979 Southern League champions with a dousing of Larry Schmittou in the showers. (Courtesy Nashville Sounds.)

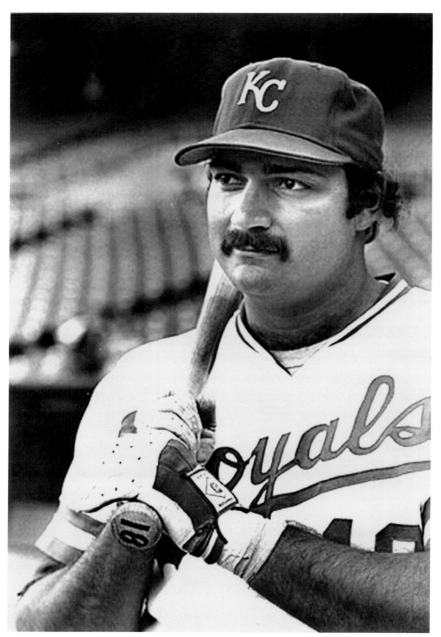

STEVE BALBONI. Steve "Bye Bye" Balboni played with the New York Yankees, Seattle Mariners, and Kansas City Royals in the majors. He earned his nickname because of his home run power exhibited in the minor leagues off and on from 1978 to 1993. In a total of nine seasons in the minors, he hit 239 home runs, drove in 772 runs, and struck out 930 times. His career minor-league batting average was .261. As a member of the Sounds in 1980, he was the Most Valuable Player in the Southern League as he led the league with 34 home runs and 122 RBI while striking out 162 times. (Courtesy Nashville Sounds.)

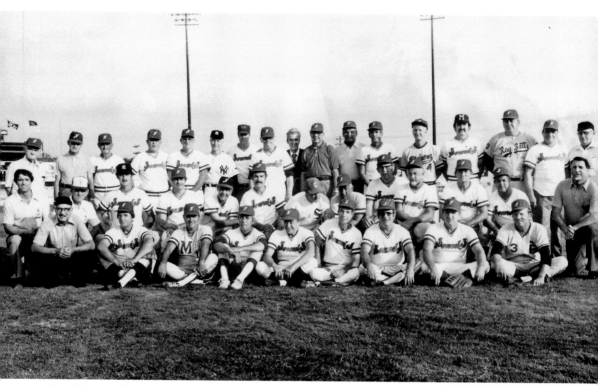

OLD TIMERS GAME. On August 13, 1981, the Nashville Sounds hosted an Old Timers game. Former players who took part in the special event are, from left to right, (first row) Paul Bush, Stan Palys, Jimmy Morrissey, Billy Isaacs, Dave Scobey, Theodore "Boots" Kirby, Bill Stinnett, Wayne Hiter, and Harry Lillard; (second row) Farrell Owens, Ragsdale "Rags" Drennan, Gene Smith, Billy Smith, Bob Elliott, Oscar Chinique, Ron Norton, Jimmy Patterson, Terry Beasley, Jimmy Miller, Roy Pardue, Jimmy Odum, and Larry Schmittou; (third row) Red Lucas, Joe Reilly, W. P. "Perk" Williams, W. G. "Dub" Allen, Jim Kirby, Jim Turner, Charlie Fentress, Clydell Castleman, Ray Stubblefield, Charles "Bama" Ray, Dick Sisler, Ray Fuller, George Archie, Gerald Johnson, Jerry Vradenburg, Lloyd Eskew, and Brice Hall. Each participant played some part in the history of Nashville baseball as a player or team executive. (Courtesy Roy Pardue.)

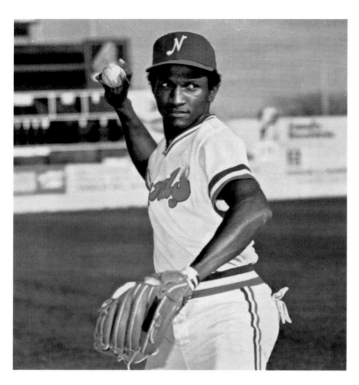

OTIS NIXON. In 1981, Nixon played shortstop for the Nashville Sounds and led the Southern League with 110 walks. In 127 games with the Sounds, he committed 56 errors and in 1983 stole 107 bases in a combined season with the Sounds and Columbus Clippers. A major leaguer from 1993 to 1999, Nixon was a career .270 hitter. (Courtesy Nashville Sounds.)

WILLIE MCGEE. An outfielder with the St. Louis Cardinals, Oakland Athletics, San Francisco Giants, and Boston Red Sox, McGee helped the Cardinals win a World Series in 1982, his first year in the majors. In 1985, he hit .353 and was the National League's Most Valuable Player. McGee played in 78 games for the Nashville Sounds in 1980 and returned to the team in 1981 to hit .322. (Courtesy Nashville Sounds.)

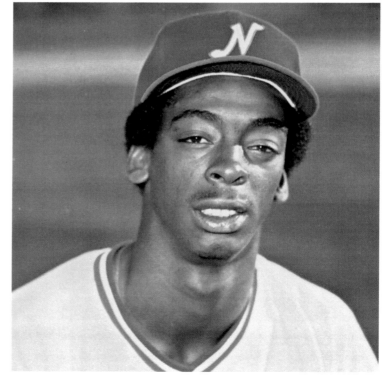

BUCK SHOWALTER. Showalter played with the Sounds for the majority of four consecutive seasons from 1980 to 1983. He ranks among the top three on the career leader boards in almost every offensive category. Showalter met his wife Angela, a former Soundette, during his years with Nashville. He was named manager of the Yankees for the 1992 season and was the American League's Manager of the Year in the strike-shortened 1994 season. He later managed the Arizona Diamondbacks and Texas Rangers. (Courtesy Nashville Sounds.)

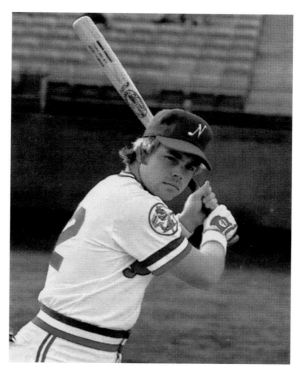

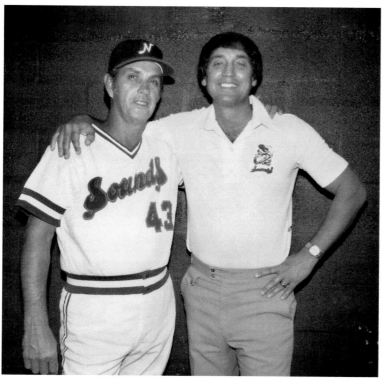

HOYT WILHELM. Elected to the Hall of Fame in 1985, Hoyt Wilhelm (left) was a Nashville Sounds pitching coach after playing for the New York Giants, Cleveland Indians, St. Louis Cardinals, Baltimore Orioles, Chicago White Sox, California Angels, Atlanta Braves, Chicago Cubs, and Los Angeles Dodgers. In 21 major-league seasons, Wilhelm's record was 143-122 with a 2.52 ERA. (Courtesy Farrell Owens.)

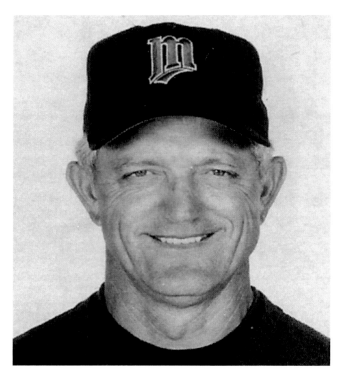

PHIL ROOF. When the Nashville Xpress moved to Nashville to share Greer Stadium with the Sounds, Phil Roof became their manager. A former major-league catcher, Roof played for several teams before beginning his coaching career. He played for 11 seasons, and his best year was in 1975, when he batted .302 in 63 games for the Minnesota Twins. (Courtesy Nashville Sounds.)

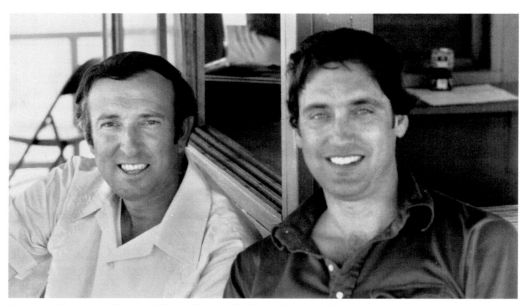

CLAUDE OSTEEN. Claude Wilson Osteen (left) was born in Caney Spring, Tennessee, and spent part of one season with the Nashville Vols in 1957, winning one and losing one. A left-handed starting pitcher, Osteen returned to Nashville in 1980 to visit with Farrell Owens at Greer Stadium after spending 18 seasons in the big leagues and finishing with a 3.30 ERA. (Courtesy Farrell Owens.)

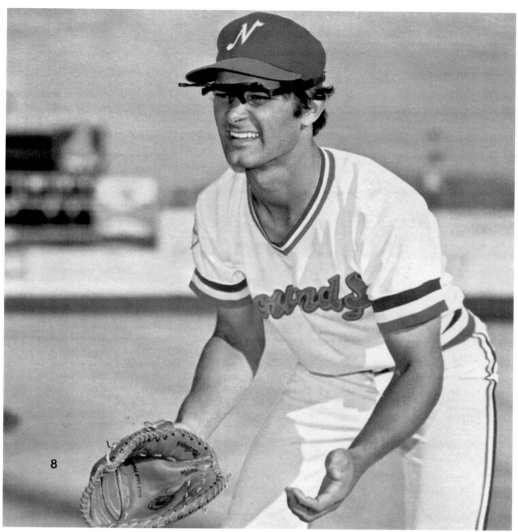

DON MATTINGLY. In 1984, Mattingly won the AL batting title with a .343 average for the New York Yankees and became the first left-handed batter to bat over .340 since Lou Gehrig hit .351 in 1937. In 1985, he was the American League's Most Valuable Player, hitting .324 with 35 home runs and 145 RBIs. His career totals in the majors include 14 seasons, all with the Bronx Bombers, and a .317 lifetime batting average. Mattingly won five consecutive Gold Glove awards at first base from 1985 through 1989. While with the Nashville Sounds in 1981, this first baseman batted for a .316 average with 173 hits and 98 RBIs. At the end of the season, Mattingly was named minor-league Player of the Year in the Yankees organization. On August 12, 1999, his number 18 was retired by the Sounds. (Courtesy Nashville Sounds.)

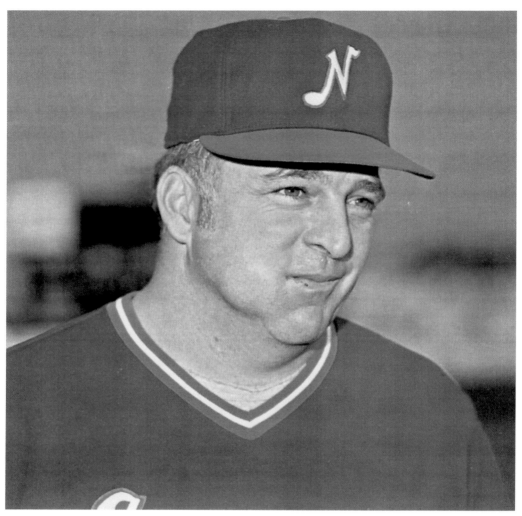

STUMP MERRILL. When the Yankees moved their affiliation to the Nashville Sounds, Merrill moved, too, leading the team to two first-place finishes in 1980 and 1981. A catcher at the University of Maine, he had managerial stints in the Carolina, Eastern, and Pacific Coast Leagues from 1966 to 1971. Before joining the Sounds, Merrill managed West Haven in the Eastern League and Fort Lauderdale in the Florida State League before joining the Columbus Clippers in the American Association. In 1990, Merrill took charge of the New York Yankees when Bucky Dent was fired in June. Stump spent the rest of that season and all of 1991 in New York. He was replaced by Buck Showalter prior to the 1992 season but continued to manage in the New York Yankees organization before joining the front office. (Courtesy Nashville Sounds.)

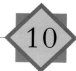

CHAMPIONSHIP
CELEBRATION

I'm happy for Nashville. It's our first year with them down there. I'm sure they're very happy that someone finally got them a title. It's a good start. The guys just battled, just like they've done all year. They kept battling and battling and got things done when they needed to.

—Nashville Sounds manager Frank Kremblas

The original owners, led by Larry Schmittou, sold the Nashville Sounds to a new ownership group beginning with the 1997 baseball season. The major-league affiliation with the Chicago White Sox was replaced by the Pittsburgh Pirates that year. In 1998, Nashville became a member of the Pacific Coast League (PCL) when the American Association was dissolved.

In 2005, the Milwaukee Brewers added Nashville to its minor-league stable. The team was stocked with future major-leaguers Nelson Cruz, Prince Fielder, and Rickie Weeks. Led by manager Frank Kremblas, the Sounds won the PCL American Conference Northern Division on the second-to-last day of the season and defeated Oklahoma (3-2) and Tacoma (3-0) during the postseason playoffs. When the team captured the 2005 Pacific Coast League championship, it was Nashville's first professional title in 23 years.

A new downtown stadium has been approved and will bring Nashville baseball back to its roots. Located at the old Thermal Transfer site on First Avenue along the Cumberland River, the facility will be operational in time for the 2008 season. Sounds general manager Glenn Yaeger has been instrumental in gaining acceptance by city leaders and fans to make the stadium a reality. As the Sounds continue the heritage begun by the Nashville Vols, Nashville Elite Giants, and Nashville Xpress, fans can look forward to a convenient state-of-the-art ballpark that will give the hometown team an exciting place to play.

PERFECT JOHN WASDIN. In 1916, Nashville pitcher Tom Rogers tossed a perfect game at Sulphur Dell, and it would be 87 years before another Nashville pitcher matched the feat. John Wasdin tossed a 4-0 victory over the Albuquerque Isotopes at Greer Stadium on April 7, 2003. He struck out 15 batters, matching a Nashville individual-game record, as 72 of his 100 pitches were strikes. Strong defensive support came from third baseman Mike Gulan, who grabbed a bullet hit by Albuquerque's Matt Treanor and made a barehanded play on a Jesus Medrano bunt to nip the Isotope at first base. It was only the second nine-inning complete game in the Pacific Coast League's 100-year history; the first was achieved by Tacoma's John Halama, who tossed his gem on July 8, 2001. The 30-year-old Wasdin was mobbed by his teammates after striking out Isotopes pinch-hitter Robert Stratton on four pitches. (Courtesy Nashville Sounds.)

GLENN YAEGER, SOUNDS GM. Serving as general manager of the Nashville Sounds, Yaeger is responsible for operations of the team. He has been the guiding force in gaining approval of new stadium construction in downtown Nashville. Yaeger is a resident of Hinsdale, Illinois, and is a Chicago Cubs fan. (Courtesy Nashville Sounds.)

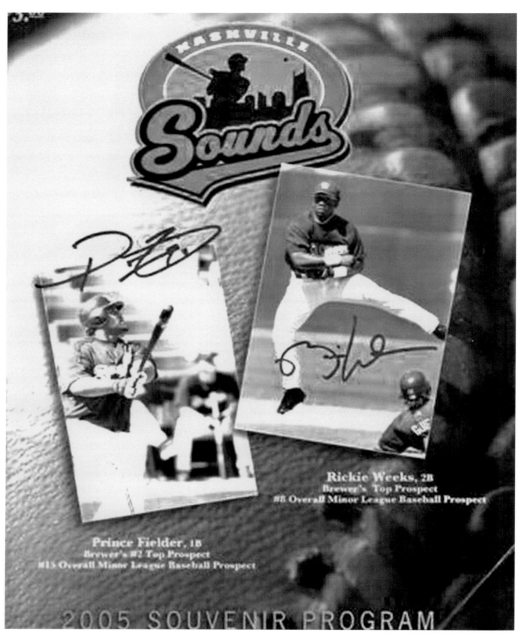

PROGRAM COVER, 2005. The Nashville Sounds changed major-league affiliations from the Pittsburgh Pirates to the Milwaukee Brewers beginning with the 2005 PCL season. Loaded with future major-league talent that included Prince Fielder, Rickie Weeks, Ben Hendrickson, Corey Hart, Dave Krynzel, and Nelson Cruz, the team put it all together to capture the first AAA championship in the history of Nashville. (Courtesy Nashville Sounds.)

FRANK KREMBLAS. Kremblas joined the Sounds as the 21st manager of the team after a successful stint at Huntsville. In his first season with Nashville, he led them to the 2005 Pacific Coast League title with a 75-69 season record. Kremblas had previously served in the Milwaukee Brewers organization as manager of the AA Huntsville Stars. He was chosen as Southern League Manager of the Year in 2003, his second season with Huntsville. Kremblas played third base and was a catcher at Eastern Kentucky University and was selected by the Cincinnati Reds in the 1989 draft. He played eight seasons of minor-league ball before beginning his managerial career in the Gulf Coast League. Kremblas also served at Cape Fear, Mudville, and High Desert before joining Huntsville. (Courtesy Nashville Sounds.)

BEN HENDRICKSON. A right-handed pitcher who relies on pitch location and is known for his "12-to-6" curveball that was rated Best Curveball in the Milwaukee Brewers organization, Ben Hendrickson was 6-12 in 28 games with the Sounds during their championship season. He finished the season with a 4.97 ERA and was sixth in the PCL with 122 strikeouts in 155 and two-thirds innings. Hendrickson averaged 7.1 strikeouts per nine innings and 5.2 innings per start while earning his first victory in a relief appearance on April 29 against Omaha. He started two games in the PCL playoffs. Born in St. Cloud, Minnesota, Hendrickson was a 10th-round draft pick by the Brewers organization. He was the Brewers minor-league Pitcher of the Year in 2004 while at Indianapolis with an 11-3 record and 2.02 ERA and was named the International League's Most Valuable Pitcher. (Courtesy Nashville Sounds.)

PRINCE FIELDER. In his fifth professional season and playing first base for the Sounds in 2005, Prince Fielder led the team with 28 homers and 86 RBIs while batting for a .291 average. During the month of May, he nailed eight home runs, drove in 27 runs, and had four two-homer games and two grand slams. Over his last 13 games of the 2005 season, Fielder hit .540 (27 for 50) before joining the Milwaukee Brewers. In the first game with each of his minor-league teams, he hit home runs (Ogden and Beloit in 2002, Huntsville in 2004, and Nashville in 2005). In 2002, Fielder was the number-one draft pick (seventh overall selection) by Milwaukee and was named Best Power Prospect in 2005 by PCL managers. Son of former major-leaguer Cecil Fielder, Prince once hit a home run into the upper deck of Tiger Stadium at age 12 while participating with his father in batting practice. (Courtesy Nashville Sounds.)

NELSON CRUZ. In 60 games with the 2005 Sounds, Nelson Cruz hit .269, socked 11 home runs, and drove in 27 RBIs after spending the first part of the season with Huntsville. In the PCL playoffs, he hit four homers and drove in 11 runs and was named the Most Valuable Player of the series. Upon joining the Sounds on June 30, Cruz slammed a game-winning home run and drove in three runs in a 6-4 win over Memphis. Born in Monte Cristi, Dominican Republic, Cruz spent time in the Oakland As farm system before being acquired by the Brewers in December 2004 along with Sounds pitcher Justin Lehr in exchange for Keith Ginter. After spending three years in the Dominican Summer League, he was originally signed as a free agent by the New York Mets. Cruz was a member of the 2004 PCL championship team in Sacramento. (Courtesy Nashville Sounds.)

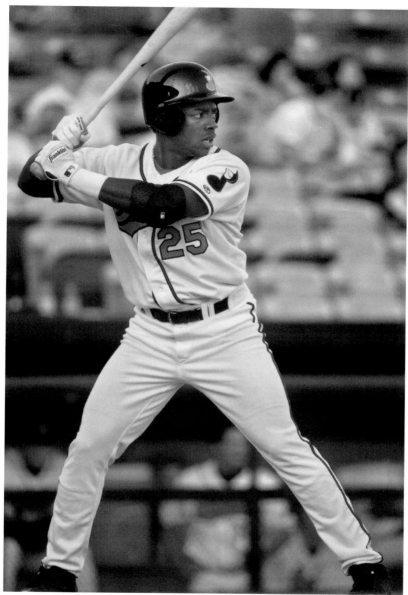

RICKIE WEEKS. Rickie Weeks, playing the first portion of the 2005 season with the Sounds before being called up by the Milwaukee Brewers, was born in Daytona Beach, Florida, in 1982 and attended Southern University. Weeks was a finalist for the 2003 Sullivan Award as the United States' top amateur athlete. A multi-talented player, the right-hander has been a top prospect throughout his career and was named the Most Exciting Player and Best Batting Prospect in 2005 by PCL managers. In a short season with Nashville during 2005, Weeks tied for the team lead with nine triples while playing second base. He batted .320 in 55 games with the Sounds in 2005, which followed a .254 season with AA Huntsville. In 2003, he was named College Player of the Year by *Baseball America* and First Team All-American. (Courtesy Nashville Sounds.)

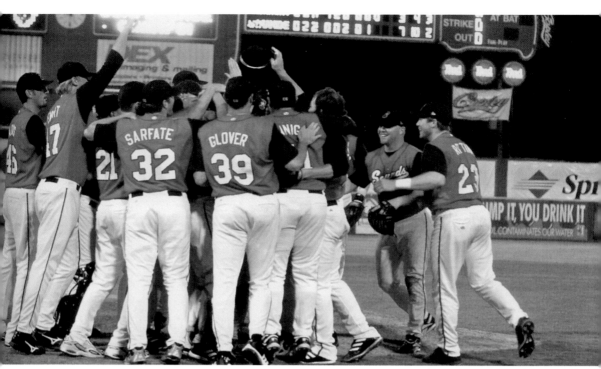

PACIFIC COAST LEAGUE CHAMPIONS. The Sounds finished in first place in the American Conference of the PCL with a 75-69 record and moved into the playoffs against the Oklahoma Redhawks. Falling behind two games to one, Nashville took 3-1 and 3-2 wins to capture the series and advance to the final round against the Tacoma Rainiers. In the finals opening game, Nelson Cruz and Tony Zuniga slammed home runs to give the Sounds an 8-6 win. In the second game, Nashville crushed Tacoma with an 11-5 win as Dave Krynzel went three-for-five and Abraham Nunez and Steve Scarborough hit home runs. In the third game, the Sounds completed the sweep by stopping the Rainiers 5-2 in 13 innings as series MVP Nelson Cruz banged a three-run home run with two outs in the top of the 13th inning for a lead Tacoma could not match. It was Nashville's first AAA and PCL championship. (Courtesy Nashville Sounds.)

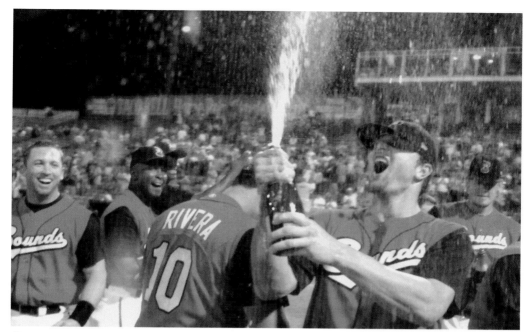

CELEBRATING A CHAMPIONSHIP. Nashville's long drought was over as the Sounds won the team's first league championship in 28 years by defeating Tacoma in 13 innings. Nelson Cruz hit a three-run home run in the top of the 13th inning to decide the game as the Sounds won the final series three games to none. (Courtesy Nashville Sounds.)

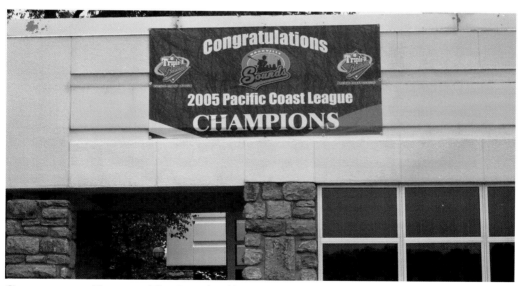

CHAMPIONSHIP BANNER. The Sounds office at Hershel Greer Stadium bears the banner that proudly proclaims the team's 2005 Pacific Coast League championship. It was the team's third league championship and first at the AAA level. The team finished 75-69 for the season and captured the American Conference regular-season title. (Courtesy Nashville Sounds.)

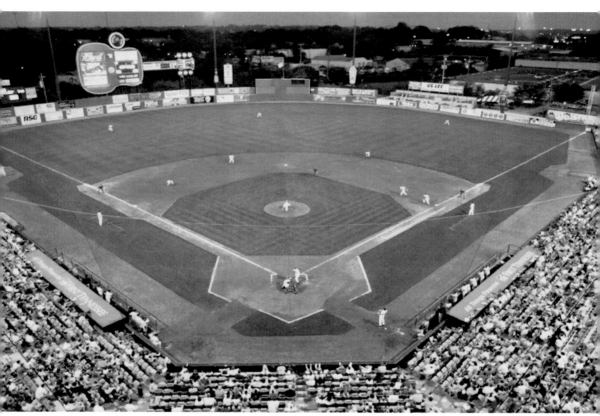

GREER LEGACY ENDS. In 1959, Herschel Lynn Greer Sr. was instrumental in forming Vols, Inc., and served as the first president of the organization, established to keep professional baseball in Nashville as support of the Vols was waning. When Nashville's baseball stadium was built to house the Southern League Nashville Sounds in 1978, Larry Schmittou and the Sounds ownership posthumously honored Greer by naming the facility after him. An avid baseball fan, Herschel Greer Sr. passed away in 1976. The ballpark has been home to the Nashville Sounds, Nashville Xpress, Belmont University, and numerous amateur and high school games. Stadium capacity is 10,139. When the 2008 season begins, Nashville will celebrate a new downtown ballpark and stadium that will be the pride of the South Broadway district and Cumberland River business area. (Courtesy Nashville Sounds.)

A NEW STADIUM. After a Nashville Metropolitan Council vote of 28-9 in favor of a new ballpark proposal, the Sounds will be moving to new downtown stadium for the 2008 season. To be built on the banks of the Cumberland River in the SoBro district on the former Nashville Thermal Transfer site, the move will allow for a state-of-the-art facility that will replace outdated Greer Stadium. The stadium will cost $43 million to build and will be a centerpiece of development in downtown Nashville. Consisting of a mixed-use plan that will include retail and residential development, the project will be headed by Baltimore-based Struever Brothers, Eccles, and Rouse. SBE&R was instrumental in developing Turner Field in Atlanta and Camden Yards in Baltimore. Joining the Sounds as program manager will be Brailsford and Dunlavy, a Washington, D.C.–based firm that will oversee the design and construction of the project. The ballpark will be located on an 11-acre tract and will seat 12,500 fans. (Courtesy Nashville Sounds.)